IMAGES
of America

BREWSTER

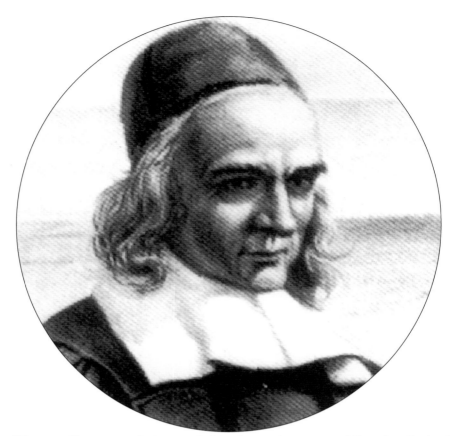

ELDER WILLIAM BREWSTER. It is recorded in the ancient town of Scrooby, England, that William Brewster (born *c.* 1565) left with members of his Pilgrim congregation in 1608 for Holland and, in 1620, for Plymouth in America, where he died on April 16, 1644. A clergyman educated at Cambridge University, Brewster was respected for his learning and piety as well as his kindness and humanity. He never sat for his portrait, but this is a 19th-century artist's conception of how he looked. (Courtesy of the Library of Congress Collections.)

IMAGES
of A M E R I C A

BREWSTER

The Brewster Historical Society

ARCADIA

Published by Arcadia Publishing,
an imprint of Tempus Publishing, Inc.
2A Cumberland Street
Charleston, SC 29401

Printed in Great Britain.

Library of Congress Catalog Card Number: 2002102509

For all general information contact Arcadia Publishing at:
Telephone 843-853-2070
Fax 843-853-0044
E-Mail sales@arcadiapublishing.com

For customer service and orders:
Toll-Free 1-888-313-2665

Visit us on the Internet at www.arcadiapublishing.com.

To Warren "Joe" Foster, who never forgot his family roots in Brewster.

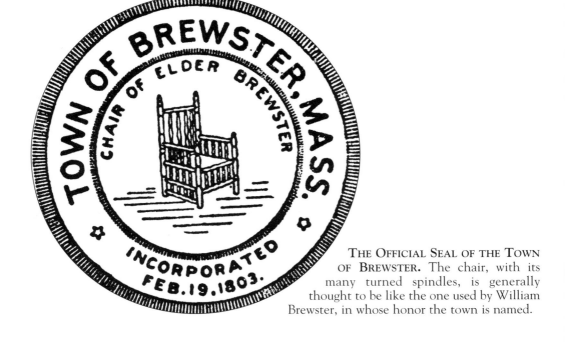

THE OFFICIAL SEAL OF THE TOWN OF BREWSTER. The chair, with its many turned spindles, is generally thought to be like the one used by William Brewster, in whose honor the town is named.

CONTENTS

ACKNOWLEDGMENTS

This book is the work of four members of the Brewster Historical Society: Henry Foster, Faith Hague, Roy Robinson Jr., and Marion Wylie. However, many friends and members of the historical society helped along the way. We would like to express our heartfelt appreciation to Mary Sicchio, special collections librarian of the Nickerson Room at the Cape Cod Community College. Thanks also go to all of the Brewster people who lent us their precious family photographs and their reminiscences: Ruth and Mary Louise Eddy, Mimi McConchie, Henry Foster, Joseph Hughes, Frances Nickerson, Dorothy Daley, Sanford Tubman, Russell Bassett, and others.

Also, we wish to acknowledge with gratitude the generous assistance of the Brewster Ladies Library, Fire Chief Roy Jones, and Lt. Mike Folcik of the Brewster Police Department.

Furthermore, the committee that created this book in celebration of Brewster's bicentennial (1803–2003) would like to remember the debt it owes to the founders of the Brewster Historical Society and its first museum curator, Mary Whitlock. It was they who assiduously collected and lovingly preserved the wonderful photographs, glass-plate negatives, and memorabilia that made this book possible. Indeed, many photographs are from the Caro A. Dugan collection, presented to the Brewster Historical Society by Donald Doane shortly after the organization was founded in 1964.

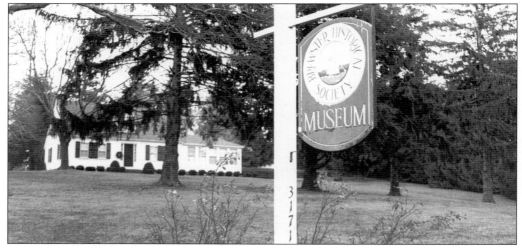

THE MUSEUM OF THE BREWSTER HISTORICAL SOCIETY. The former Castiglioni house, built c. 1840, was acquired by the town as part of a conservation land purchase in 1985 and was extensively renovated by the Brewster Historical Society. The museum is located on Main Street in East Brewster. The Brewster Historical Society was established in 1964 "to create and foster an interest in the history of the Town of Brewster; to promote historical research; to collect and preserve documents and relics and to provide for their custody."

INTRODUCTION

Here is Brewster, represented in photographs taken during an era that is long gone by. To be sure, there are still many cranberry bogs, houses, and churchyards that recall the old days, but the exciting age of seafaring, stagecoaches, and even trains is a memory except in books and old photographs. Brewster people are fortunate, however, in that some unique historical features were preserved, such as one of the town's gristmills (with an overshot waterwheel), one of its early windmills, its first library, and its original town hall. This book is a fond look back at some of Brewster's people and its landmarks. It is also a proud commemoration of its 200th birthday.

In 1806, three years after the prosperous North Parish of Harwich was incorporated as a separate town named Brewster, Rev. John Simpkins wrote a description of the region. His account provides us with a fine contemporary picture of the village. Life in the village centered on the first meetinghouse, which was built in 1700 and was later enlarged to accommodate the growing population. Simpkins described the diversity of the terrain, its many fine views of the Atlantic Ocean, the large number of freshwater ponds, and areas of fertile soil for agriculture.

There were orchards and cattle, woodlands and hayfields, peat in the swamps, and, most happily, "a never-failing supply of water to a grist mill and a fulling mill." Simpkins did not overlook the vast migration of herring in the spring months. They made their way up Paine's Creek to Stony Brook and into the Mill Pond and the headwaters beyond. This stream, a drop of 26 feet from the ponds to the sea, provided all the waterpower required to turn the wheels of the mills in that remote area in western Brewster. It was called Factory Village, one of the earliest industrial sites in America.

The climate was described as "conducive to health," no small consideration in those days. As the community struggled and sometimes prospered, an ever-growing proportion of the young men of the town left farming and turned to the sea, either in the fisheries or coastal shipping. Simpkins thought that Brewster inhabitants of those times were industrious, enterprising, hospitable, social, abstemious, friendly, and in favor of education for their children. He also thought it worth noting that their homes were well tended and neat. We know this to be true because more than 200 of them still survive after more than 200 years, despite hurricanes, winter gales, and powder post beetles.

A century later, shipping magnate J. Henry Sears wrote in *Brewster Shipmasters,* a personal tribute to the commanders of vessels who lived in Brewster, "It is believed that more shipmasters engaged in foreign trade went from the town of Brewster than from any other town or place in the country, in numerical proportion to its inhabitants. From a population numbering about 1,000 people we have the names of one hundred and fifteen shipmasters living since the year 1840, and during the year 1850 there were over 50 living there at one time. . . . Most of the young men in the town who followed the sea became masters of vessels engaged in trade to all parts of the world." They generally had a financial interest in or were part owners of the ships they commanded.

This period in Brewster's history, the first half of the 19th century, is key to understanding the character of the town. Although many men were lost to the sea—11 members of one Crosby family—the fact is that despite incredible danger, a great many shipmasters returned to their fine homes and cultivated acres. They went on to become (in retirement) civic leaders,

church elders, businessmen, and influential citizens of the community. Their memoirs and souvenirs inspired a great interest in the world beyond. Many Brewsterites knew more of Canton, China, or Bombay than they knew of Philadelphia or Boston. The maritime history of that era of tall ships is quite extraordinary and, in fact, sets the Cape apart from most of the country. While each town from Sandwich to Provincetown has a claim to this glorious past, Brewster led them all and is therefore unique.

The men who did not engage in the seafaring trade had other options. Some families turned to the business of making salt from seawater. Salt was needed commercially to preserve fish, and the shores of Cape Cod Bay were ideally suited for that process. Great shallow wooden vats covered many areas in Brewster, such as Wing's Island and Robbin's Hill Beach. Water was pumped into the vats, and the sun evaporated the water, leaving salt. This process was quite primitive at first, but by the beginning of the 19th century, improvements had been made that resulted in considerable profit to the investors. Then there was the cultivation of cranberries and, in 1865, the coming of the railroad; many more markets were available for farm products, fresh fish, and, eventually, tourists.

No story of Brewster could be complete without mentioning the impact of the trains on the people of the Cape. The local train stations became hubs of activity for each town. Everything—the mail, the arrival of family, and shipments of every sort from all over the country—came and went by the railroad for over a century. It was a rare time for Brewster, connecting it to great world events. As new visitors arrived and departed each day, many vowed to return in order to find a still unspoiled, unchanged way of life that is part of the Brewster state of mind today.

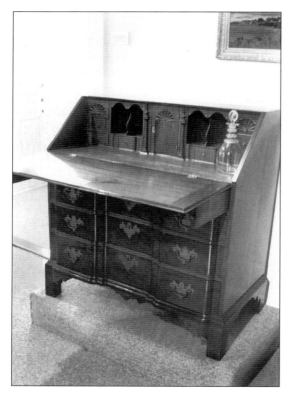

A TRANSITIONAL BLOCK-FRONT MASSACHUSETTS DESK. This desk is said to be the one used for the signing of the articles of agreement that separated Brewster from Harwich in 1803. It was donated to the Brewster Historical Society by descendants of the Winslows of Stony Brook and Satucket Roads—Mary Cleverley and Mimi Cleverley McConchie.

One

THE STRUGGLE
FOR EXISTENCE

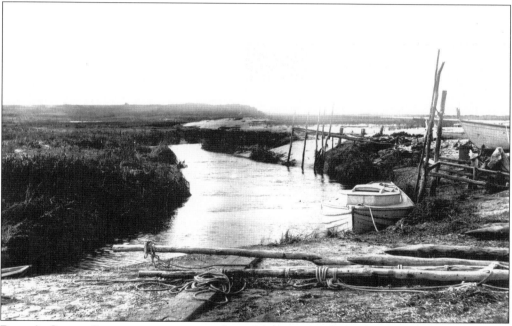

PAINE'S CREEK, LOOKING ACROSS THE SALT MARSH. It is through this unimpressive stream that millions of herring make their way each spring, much to the delight of the waiting crowds, to spawn in the freshwater ponds south of Stony Brook Road. The Native Americans knew about this valuable renewable source of protein, and the early Colonial settlers quickly picked up on the many uses of herring and the availability of wild game that depended on fresh water. Today Paine's Creek is a gorgeous destination for photographers, fishermen, painters, walkers, and lovers of perfect sunsets.

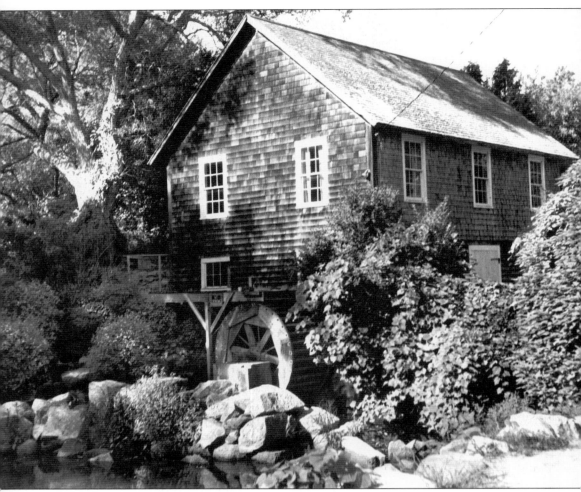

THE OLD WATER-POWERED GRISTMILL. The history of this gristmill begins more than 300 years ago when Thomas Prence of Eastham purchased the land from the Native Americans. In 1663, he built the first water-powered gristmill on Saquatucket Brook (now called Stony Brook). It was used to grind corn, a staple of great importance to the early settlers. A short time later, Kenelm Winslow, John Dillingham, and Joseph Wing built a fulling mill nearby. This gristmill was built in 1873 on the foundations of the earlier mills that burned down.

THE PRESENT-DAY GRISTMILL. This old photograph shows the gristmill (right) and the stone bridge that crossed the brook.

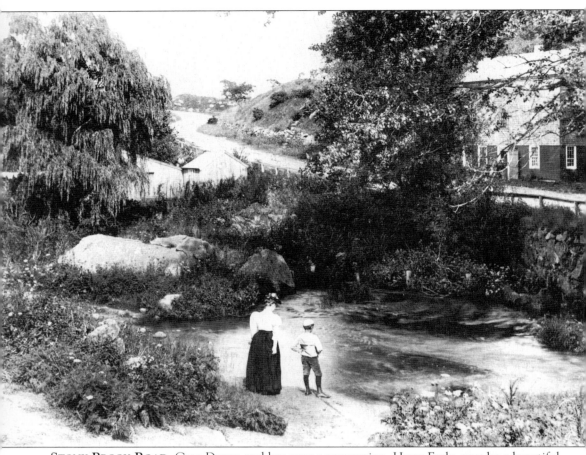

STONY BROOK ROAD. Caro Dugan and her young companion, Harry Earle, pass by a beautiful spot along the Herring Brook in 1894.

THE JOSEPH MCLOUD HOUSE AND TAVERN. Located next to the gristmill, this house served as a stagecoach stop when Stony Brook Road, joined by Satucket Road, was the main thoroughfare from the west to the northeast. Henry David Thoreau must have come this way on his famous travels to Cape Cod in the mid-19th century. Joseph McLoud's son Anguish distinguished himself fighting in the American Revolution.

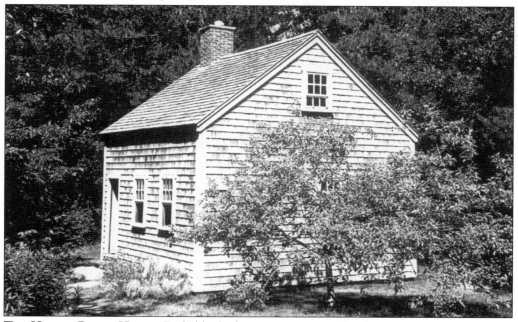

THE HARRIS-BLACK HOUSE. Probably the last surviving example of a one-room primitive post-and-beam structure in Brewster, this house was built in 1795 by John Harris, a seafaring man, and his wife, Sarah. Although the evidence is sketchy, it is likely that the family was Native American. Their daughter Elizabeth was born in 1803, the year Brewster was incorporated as a town. She married Nate Black and had 11 children in this house. It was acquired by the Brewster Historical Society in 1984.

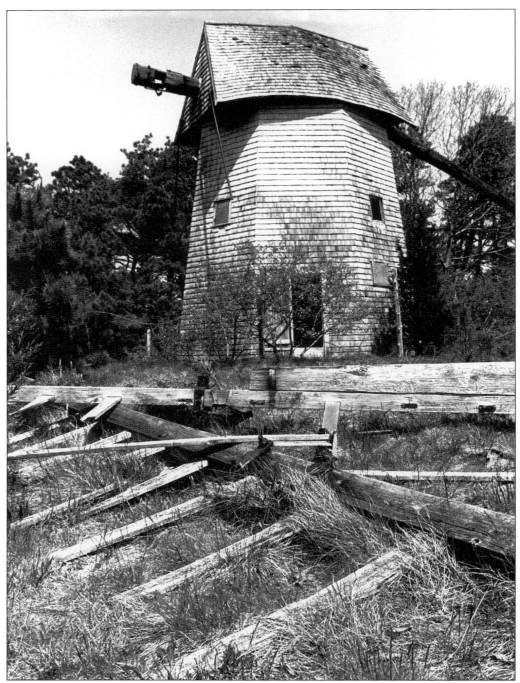

THE OLD MILL. "Your dear arms seem to stretch out in loving embrace to me. December 26, 1898 T.F.P." These poignant words were found penciled on the stairway of the old Higgins Farm Windmill. The photograph was taken before the Nickerson family gave the windmill to the Brewster Historical Society and before it was moved to its permanent new site in 1974. It speaks volumes about the visual impact these humble structures must have had on the countryside.

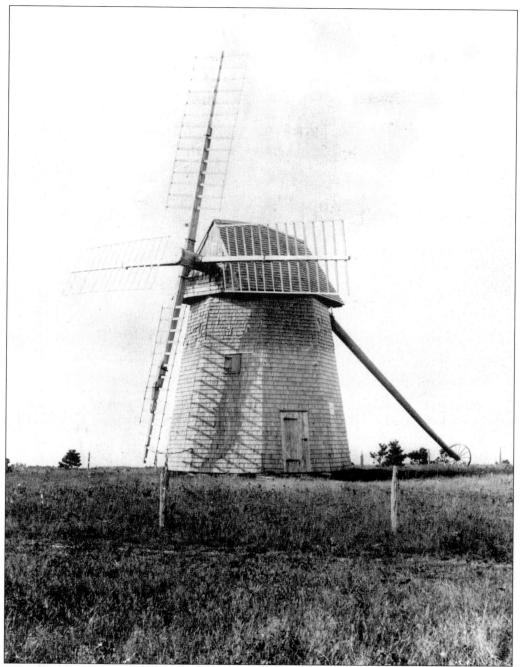

THE HIGGINS FARM WINDMILL. Built *c.* 1795, the Higgins Farm Windmill was originally owned by several farmers and was moved a couple of times. Its final location was Ellis Landing Road (part of the Nickerson estate), where it was used by the family as a clubhouse. The last owner, Mrs. Samuel Nickerson, donated it to the Brewster Historical Society in memory of her late husband. It is maintained by the Brewster Historical Society and is open for tours during the summer months. The site was donated by Mr. and Mrs. Tony McGowan.

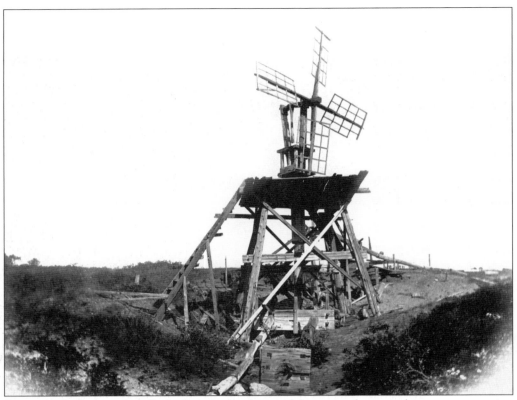

Brewster's Saltworks. Built close to the shores of the town, these cumbersome connecting structures of wooden vats, pipes, and windmills were used to manufacture salt during the late 18th century and well into the 1850s. The windmills pumped seawater into great holding tanks with rotating covers, which allowed natural evaporation to take place. The result was an array of salts, which provided an income to local owners so valuable that during the War of 1812, Brewster actually paid a ransom of $4,000 to the British not to fire upon the wooden saltworks. It was a dark day in the annals of Brewster, but without defenses, Capt. Elijah Cobb, one of the town's most influential leaders, took up the collection to pay Capt. Richard Raggette of the HMS *Spencer*.

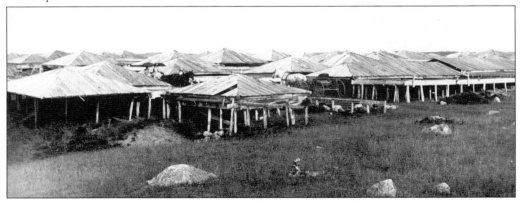

One of the Old Brewster Saltworks. In 1809, there were between 60,000 and 70,000 feet of saltworks within the town of Brewster.

16

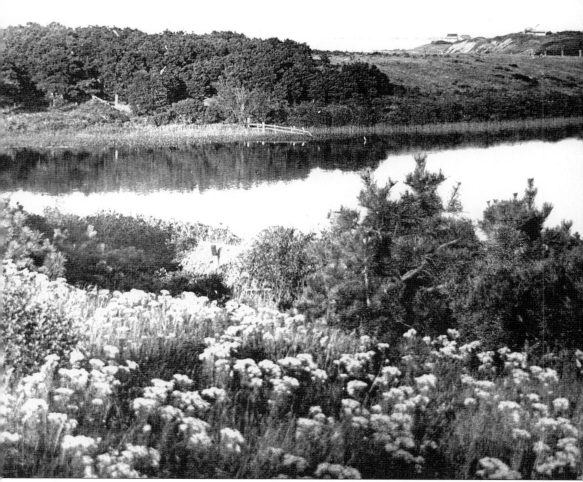

COBB'S POND IN SPRING, WITH CAPE COD BAY IN THE DISTANCE. There were at least two icehouses on this large pond for many years. Cutting ice was a big business for Brewster because of its many freshwater ponds. In winter, the ice was cut with special equipment and stored in the icehouses, insulated with straw.

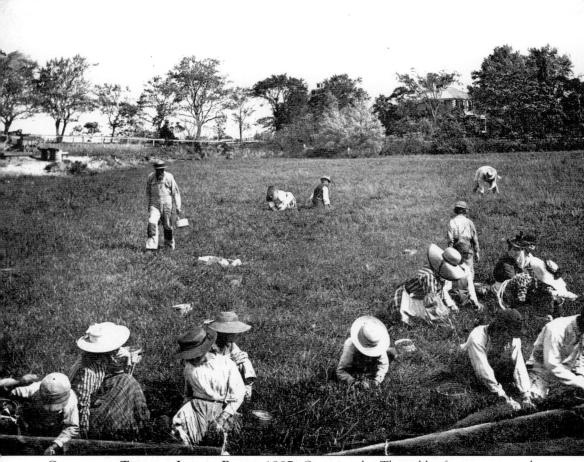

CRANBERRY TIME ON LOWER ROAD, 1887. Opposite the Thorndike farm were vast bogs. Author Joseph Lincoln recalled that in his boyhood, before 1900, picking cranberries yielded 1¹/₂¢ per quart. The opening of school was delayed a month until early October so that whole families could pick. They would crawl through the vines for eight hours a day on their knees. The young boys thought of it as a lark, but to the adults it must have been hard work. The Massachusetts Wampanoag Indians knew about the value of eating wild cranberries mixed with other food staples, but colonists added the tart berries to their desserts and sauces, breads, and stews. Also, mariners carried them aboard their sailing vessels in barrels. Like lemons and limes, cranberries were known to ward off deadly scurvy.

Two
BUILDING A PERMANENT SETTLEMENT

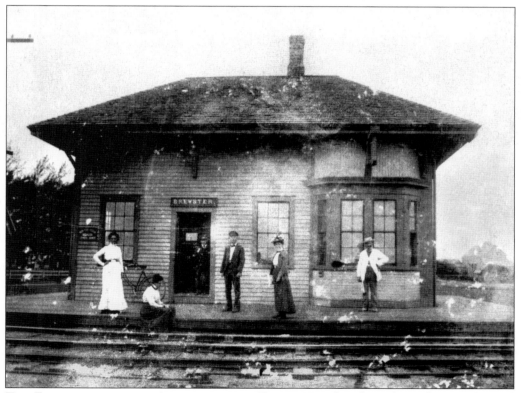

THE EXCITEMENT OF THE ARRIVAL OF THE TRAIN. Traveling by rail was faster, safer, and cheaper than sailing the packet boats. By 1865, the railroad had reached Brewster. People flocked to the Cape once the trains came through.

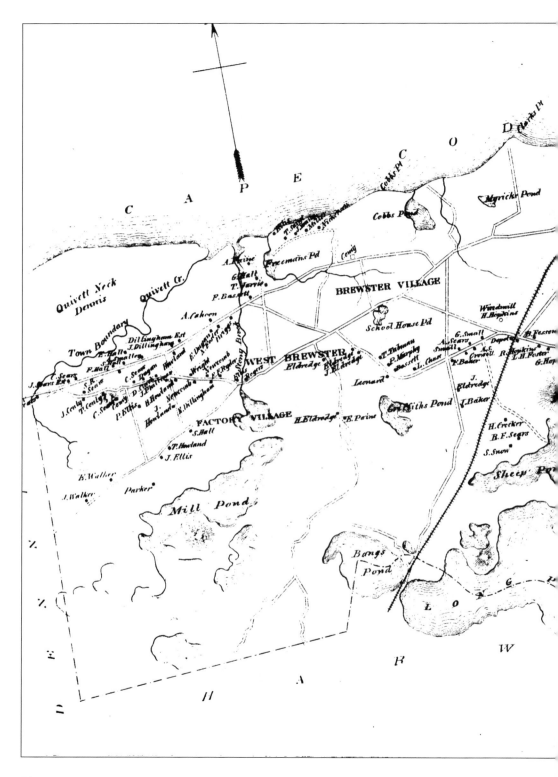

20

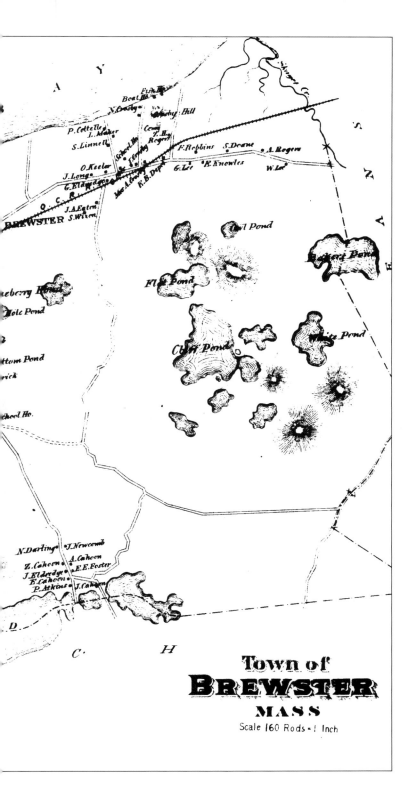

A **Y**

A

Boat H.

Fish H.

N. Crosby

Crosby Hill

P. Cottelle

I. Maker

Corn H.

T. H. Rogers

S. Linnell

School Ho.

F. Freeman

F. Robbins

S. Doane

A. Rogers

O. Keeler

G. Lee

E. Knowles

W. Lee

J. Long

Mrs A. Crosby

R. R. Dep.

G. Eldredge

O. C. R. R.

J. A. Eaton

BREWSTER S. Wixon

Owl Pond

Flax Pond

Hackert Pond

uebersy Pond

White Pond

Mole Pond

Clift Pond

ttom Pond

rick

chool Ho.

N. Darling J. Newcomb

Z. Cahoon A. Cahoon

J. Eldredge E. E. Foster

E. Cahoon

P. Atkins J. Cahoon

D

C

H

Town of

BREWSTER

MASS

Scale 160 Rods = 1 Inch

A MAP OF BREWSTER.
The railroad came
through town in 1865,
connecting Harwich
with Brewster, as
shown on this late-
19th-century map. The
tracks intersected with
Main Street just east
of Crosby Lane.

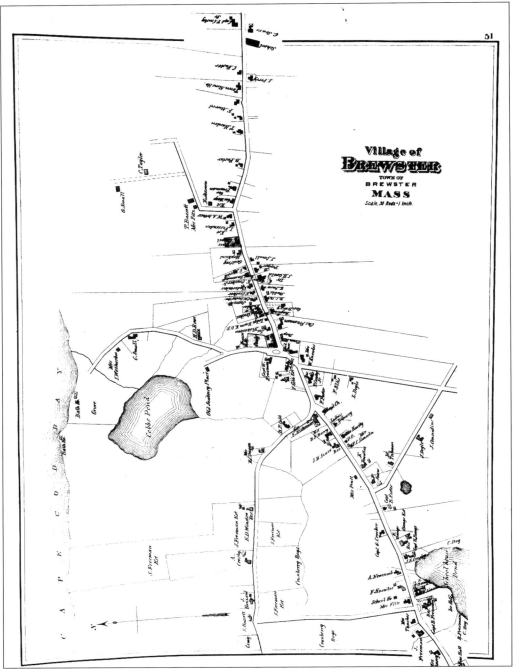

THE 1880 MAP OF THE VILLAGE OF BREWSTER. This map gives the locations of the houses and businesses concentrated in the central part of the town, along with the church and library.

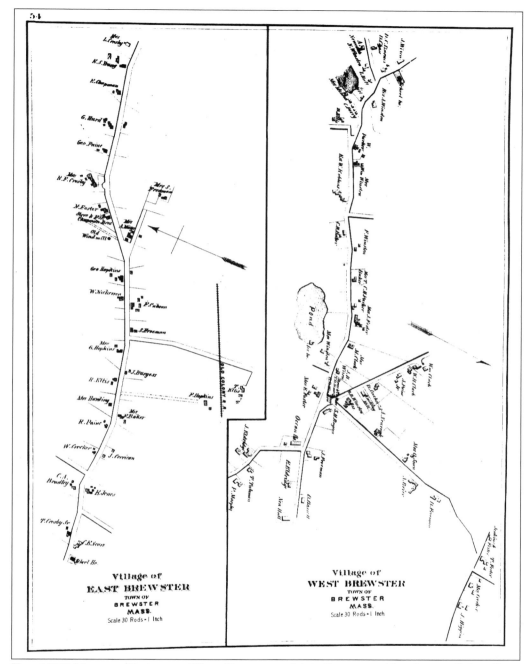

THE 1880 MAPS OF EAST AND WEST BREWSTER. Main Street ran 11 miles parallel to Cape Cod Bay in an east-west direction.

23

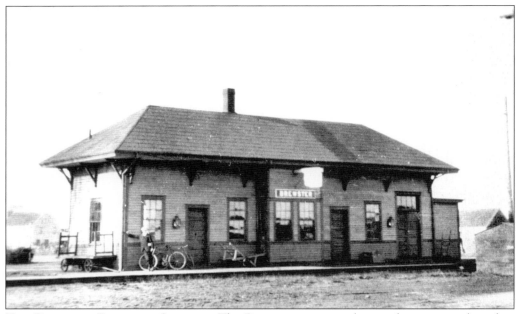

THE BREWSTER RAILROAD STATION. The Brewster station is shown after it was enlarged to handle more baggage. Below, you can just see the conductor next to the passenger cars. On the left is an old station wagon.

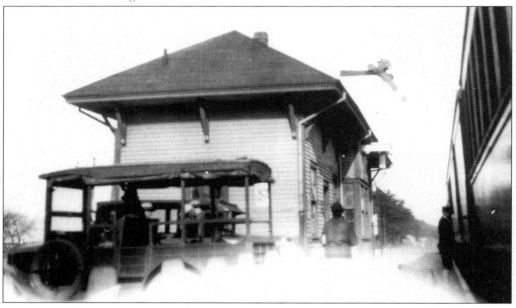

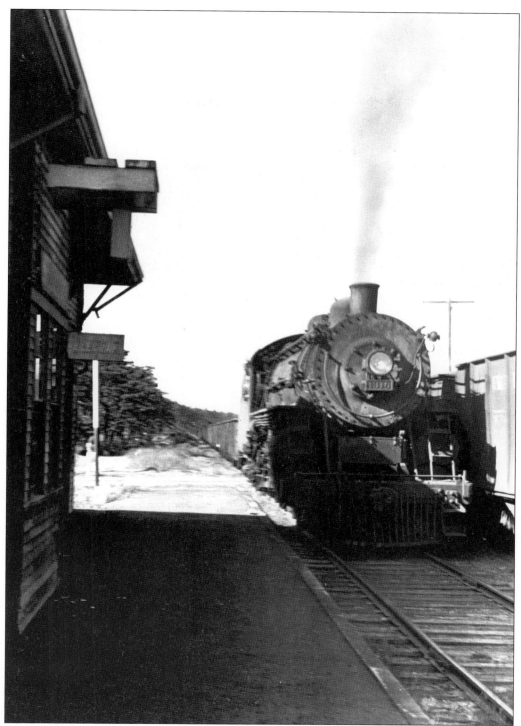

THE MIGHTY STEAM ENGINE IN BREWSTER STATION. A steam engine is returning with empties (freight cars) from Provincetown *c.* the 1930s. Route 137 crosses the tracks behind the engine.

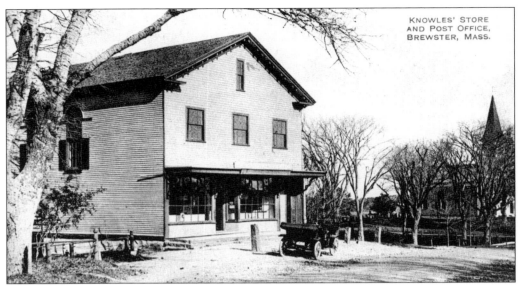

THE BREWSTER GENERAL STORE. The Brewster General Store was originally built as a church by the Universalists in 1852. This was the era of church building for this group, but their numbers quickly faded. By 1858, the Italianate structure, with its bracketed styling and distinctive tower, was severely modified and converted to a general store. Some people believe the building was raised up one story, accounting for the unusual size and arrangement of windows. The store also housed a post office. A meeting place and center of town life, it came to embody the sociability and spirit of Brewster and remains so to this day.

MADDIE GODFREY. Maddie Godfrey was born in 1867 in an ancient half house on Point of Rocks Road. Her father, Amos Godfrey, sailed a packet between Brewster and Boston. Her grandfather ran the old mill in Chatham. As a young woman, she held several jobs, including bookkeeper and clerk for Chapman Brothers in East Brewster. Later, she went to work for W.W. Knowles at the general store. She was the clerk and then an assistant in the store's post office from 1905 to 1936. Everyone knew her and had the fondest memories of her.

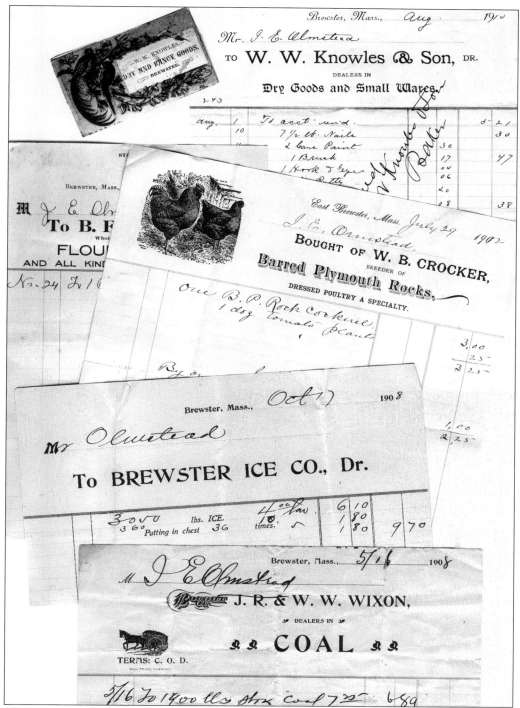

BREWSTER LETTERHEADS. This selection of business letterheads illustrates the diversity of Brewster's commerce and the pride of its business community. W.W. Knowles's business card (top), printed in a rainbow of colors, reveals the man's appreciation of the power of advertising.

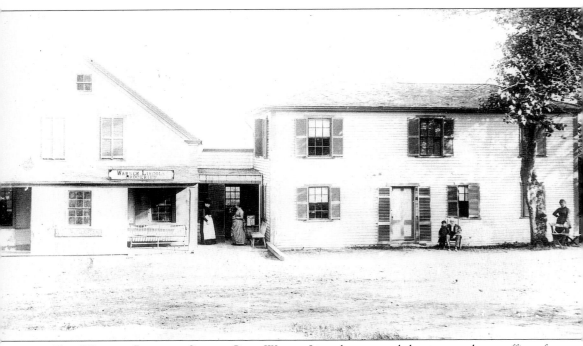

THE WARREN LINCOLN STORE. Capt. Warren Lincoln operated the store and post office after he retired from the sea c. 1850. His house was attached to the store and was eventually sold and moved directly across the street, where it still stands, facing Schoolhouse Pond. Lincoln lived a remarkably long life, surviving many early adventures at sea, including being captured by pirates in 1822 while serving aboard the brig *Iris*. It was an extraordinary story and must have caused a sensation when he returned safely to Brewster.

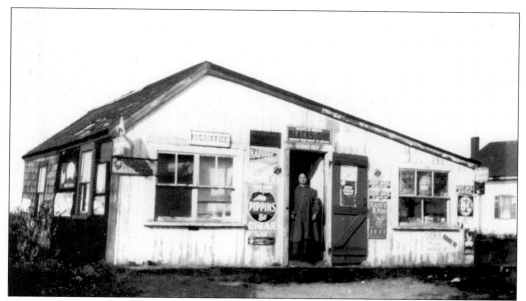

THE WEST BREWSTER POST OFFICE, MAIN STREET. The battered ghost of this little building still stands in a wild thicket of trees and shrubs, a reminder of the early part of the 20th century, when little general stores with a post office still flourished on the Cape. In this 1880s photograph, postmaster Rebecca Dugan stands in her doorway.

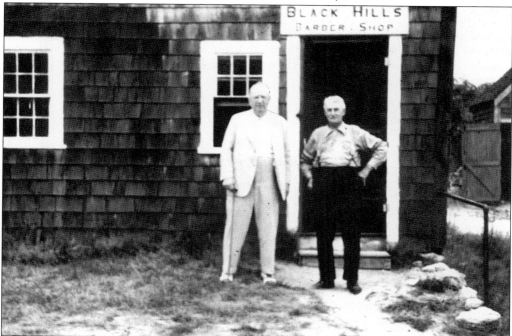

NATE BLACK, BARBER. Nate Black (right) is pictured with one of his longtime patrons, Charles A. Keene, in front of the old barbershop on Red Top Road in West Brewster. Happily, the contents of the barbershop survive in the museum of the Brewster Historical Society. Black's business card reads, "60 years in business—still going strong."

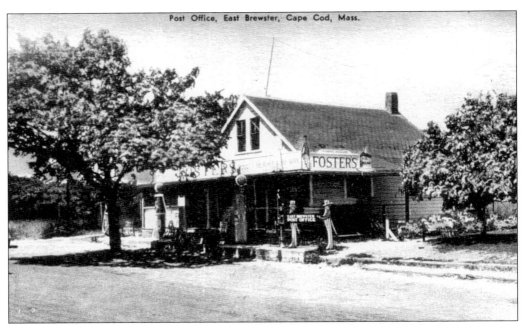

FOSTER'S PACKAGE STORE INCLUDED THE EAST BREWSTER POST OFFICE. The first postmaster was George W. Higgins. Mrs. Mertis L. Foster took the reins in 1919 and served until 1957, when her adopted son, Arthur Coakley, became the last postmaster of the little post office in East Brewster. Coakley sent Christmas cards with personal messages about the Cape to his summer patrons, a treasured measure of his kindness. He retired in 1972.

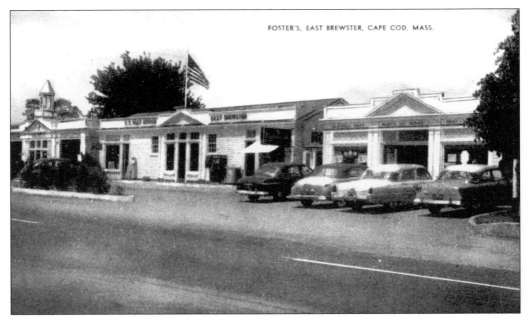

FOSTER'S, EAST BREWSTER, CAPE COD, MASS.

FOSTER'S, EAST BREWSTER, C. 1948. After several renovations, the entire row of stores, along with the East Brewster Post Office, was demolished and Foster's Square built in its place, changing the face of Brewster's little commercial center forever.

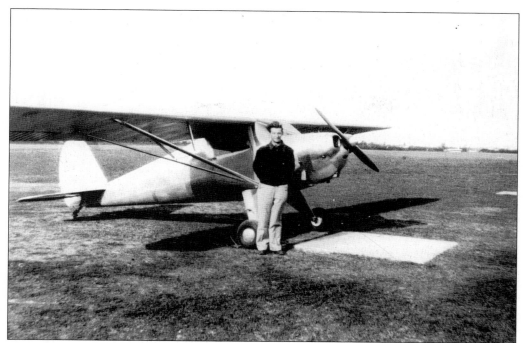

ARTHUR COAKLEY. Appointed assistant East Brewster postmaster in 1935, Arthur Coakley had learned to fly the Hyannis Flying Club's airplane, a Luscombe single engine. By 1938, he was flying Brewster's mail aboard, landing on the nearby Brewster Golf Course. He had his own cancellation airmail stamp and even issued a first-day cover to commemorate the event. Beginning in 1930, one of Arthur Coakley's jobs was to drive to the East Brewster railroad station three times a day to pick up the mail. He enjoyed these trips, as Fred Nash was station agent, and Coakley would help him unload the mail and also the large trunks from the train.

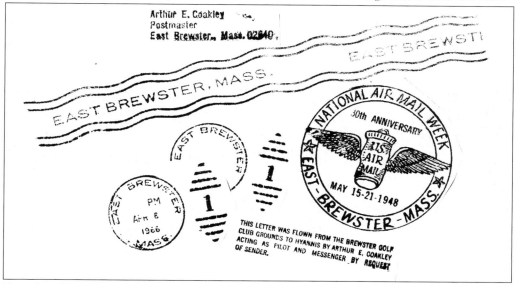

THE OLD EAST BREWSTER POST OFFICE'S CANCELLATION STAMPS. Coakley used his own winged airmail cancellation stamp for the letters he flew to Hyannis.

31

LOOKING WEST ON MAIN STREET, NEAR THE CENTER OF TOWN. On the left is the Captain Benjamin Freeman House. On the right is District School No. 2 (Brewster High School). The structure, somewhat altered in appearance, still stands. Brewster's only high school became the plastics factory, a somewhat incongruous building with many additions at the back, for the manufacture of baby bottles. In this *c.* 1900 photograph, Main Street is still a dirt road with scarcely any charm to recommend it.

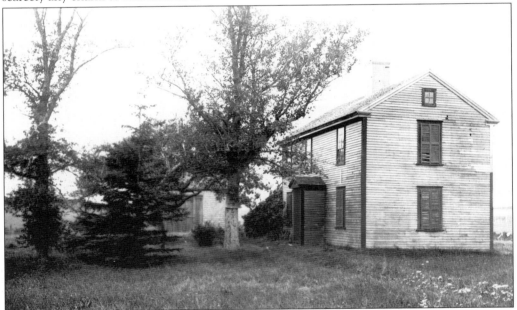

THE CAPTAIN WEATHERBEE HOUSE. Built on Breakwater Road in 1843, the one-room floor plan is quite unique in Brewster. When the entire property was willed to the Brewster Conservation Trust with the stipulation that the house be removed, a young family purchased the house for $1 and is currently restoring it on land in West Brewster. This photograph was taken in 1910.

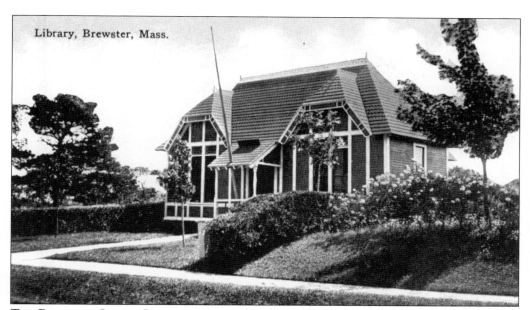

Library, Brewster, Mass.

THE BREWSTER LADIES LIBRARY. Designed in the Stick, or Craftsman, style in 1868 (unusual for Brewster in those days), the Brewster Ladies Library stood out from everything around it. Next door to the Baptist church, a stone's throw from author Joseph Lincoln's house, it was not only located in the heart of the town, it was the heart of the town. It has been enlarged over the years, but the original structure has been carefully preserved.

SARAH AUGUSTA MAYO (1830–1888). A genealogist and one of the founders of the Brewster Ladies Library, Sarah Augusta Mayo authored *History of Brewster and Personal Reminiscences c.* 1880. The volume recorded the social life of Brewster in the mid-19th century. Mayo was regarded as a leader of the intellectual circle of ladies that flourished in the town at that time.

33

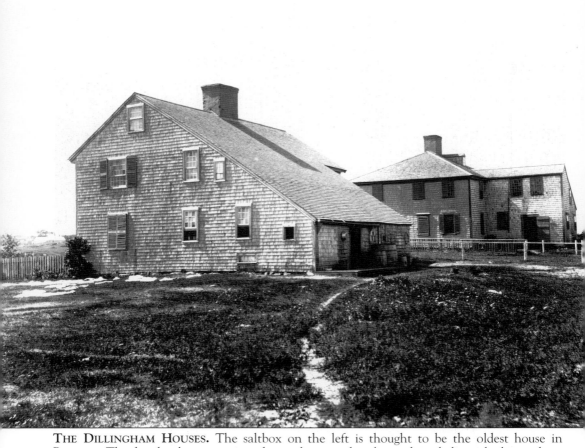

THE DILLINGHAM HOUSES. The saltbox on the left is thought to be the oldest house in Brewster. The date has been questioned over the years, but descendants believe the house dates from 1660. It was built by John Dillingham, a Quaker who was born in England and emigrated with his family to Lynn in 1632. In 1637, the Dillinghams moved to Sandwich on the Cape. As a young man, John Dillingham decided to strike out on his own and moved to the wilderness of what was then Yarmouth. The area later became Harwich and, in 1803, separated from Harwich to become Brewster. Next door was another Dillingham house (right), which was built much later and was moved in the 1950s to Barnstable, overlooking Barnstable Harbor.

A PICTURESQUE HOUSE. Probably built in 1824, this house is located on the corner of Percy Newcomb and Stony Brook Roads. Roxanna McLoud of Brewster married Elisha Howland of Dennis. Her family, long established in West Brewster, may have given them the land as a wedding present. They had eight children. One of Roxanna's sons lived in the house through the early 20th century. By the 1920s, the house had passed out of the Howland family.

THE EDWARD SNOW HOUSE. This house, one of the oldest in Brewster, dates from 1700. Edward Snow was one of the first supporters of the First Parish Church. His house has a prominent location across the way from the church in the center of the village.

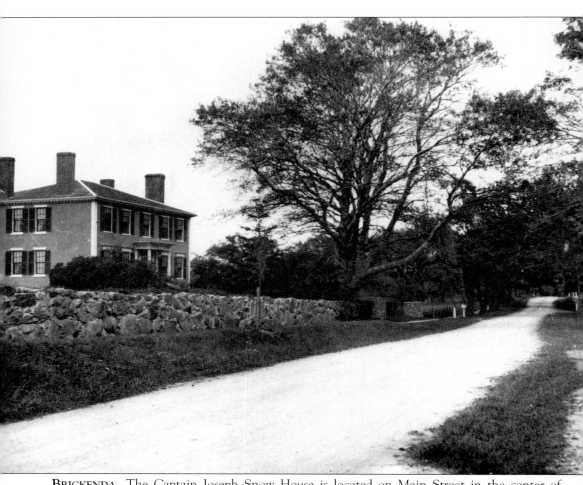

BRICKENDA. The Captain Joseph Snow House is located on Main Street in the center of Brewster. This exceptional house, built *c.* 1793 in the Federal hip-roof style with four handsome chimneys, is unique, for both of its end walls are made of brick. Snow was lost at sea during a voyage at the very young age of 26.

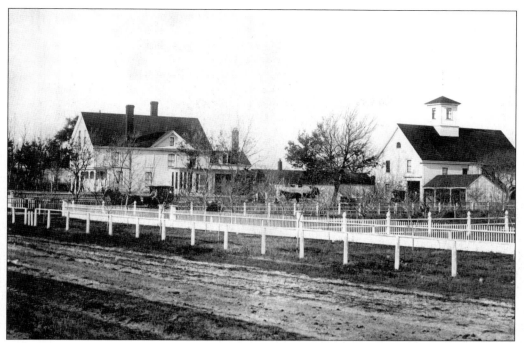

THE PINES. This handsome property is shown before Main Street was paved, probably around the time when Albert Crosby retired to Brewster and lived just down the lane in his mansion Tawasentha. This was a time when the Crosbys were very prosperous and owned a great deal of land in East Brewster, including the Pines.

EAST BREWSTER'S OWN SMALL BUSINESS CENTER. The Higgins House faced the Chapman Brothers Store and Post Office, just out of view to the left. The house still stands in its original location on Main Street. The store was eventually moved across the street and converted to a private home. Ellis Landing Road ran from the left of the store to the beach.

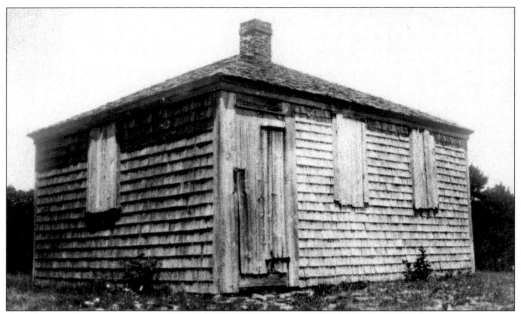

THE ONE-ROOM SCHOOLHOUSE ON LONG POND ROAD, SOUTH BREWSTER. There were eight grades under one teacher in this building. Typically, the first four rows had small chairs for the young children and larger chairs behind for the older students. There would have been a wide aisle down the center, with boys on one side and girls on the other. A tall coal-burning iron stove sat in the center of the room to keep the class warm in the winter. In 1887, this was one of the five schools in Brewster. The schools served 172 scholars in all.

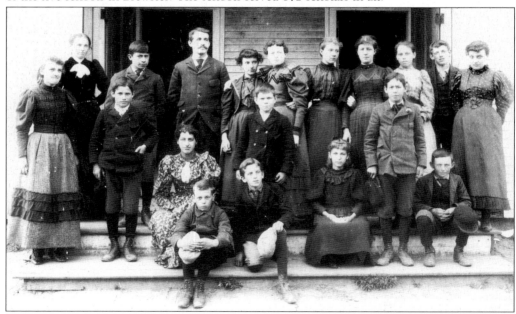

THE CLASS OF 1897. At District No. 2 School, Beulah Eldridge stands in the back row next to Dr. L.A. Crocker. This photograph of her graduating class was given to the Brewster Historical Society by Eldridge.

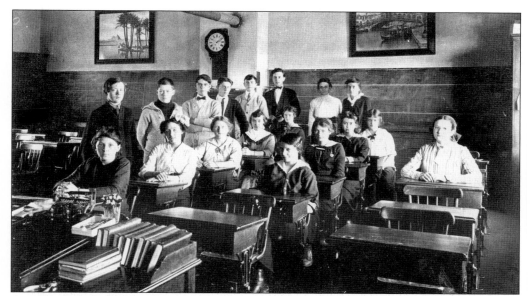

AT THE OLD SCHOOLHOUSE, 1909. The principal at the Brewster High School was a Mr. Fognell. The boys standing to the left are, from front to back, Raymon Tubman, William Reed, Leland Eldredge, Alston Cahoon, George Foster, and Ernest Chase. Although their exact positions are not given, the girls include Florence Chase, Beth Chapman, Elizabeth Burgess, Marion Nelson, Bessie A. Baker, Marion Baker, Katherine Eldredge, and twin sisters Cora and Ida Young.

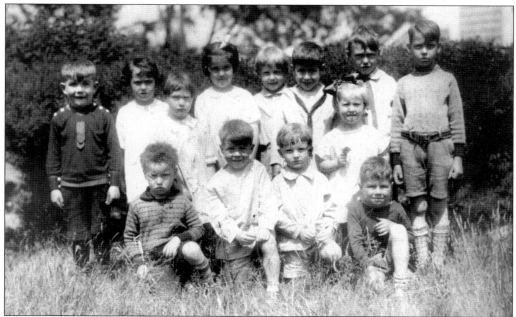

A KINDERGARTEN CLASS, 1929. From left to right are the following: (front row) Ernest Gage, Kenneth Chatfield, Gordon Eldridge, and Joe Coggeshall; (middle row) Alice Linnell and Mary (Mimi) Cleverley. The back row includes Theodore Ellis, Jane Garrows, Louise Crocker, Howard Eldridge, Sheldon Curtis Linnell, and Miller Bassett.

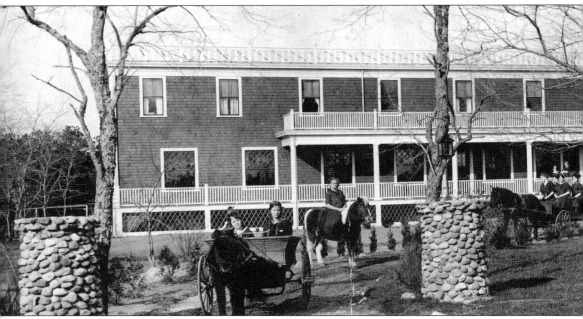

THE SEA PINES SCHOOL OF PERSONALITY EDUCATION. This school began as a summer camp in 1907. By 1910, the first building went up to accommodate girls who wished to remain as year-round students. The school, headed by Rev. Thomas Bickford, quickly grew. In an idyllic

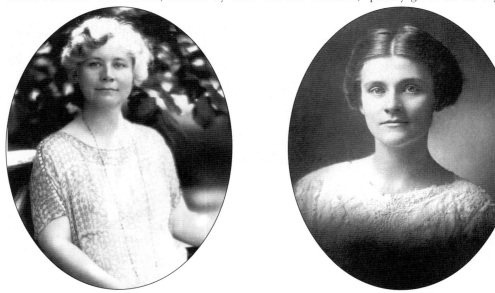

LEFT: **FAITH BICKFORD.** It was this young woman who first suggested to her parents that they start a summer camp in Brewster. Bickford devoted her entire life to the place that simply kept growing. It became a beloved home to generations of girls who to this day think of it as a shrine to good health, good times, and wonderful memories, as well as a fine education. *RIGHT:* **ADDIE FRANCES BICKFORD.** The daughter of Rev. Thomas Bickford, Addie Frances Bickford was known for her poetry. She was born in 1886 and died in 1927, three years before her mother passed away.

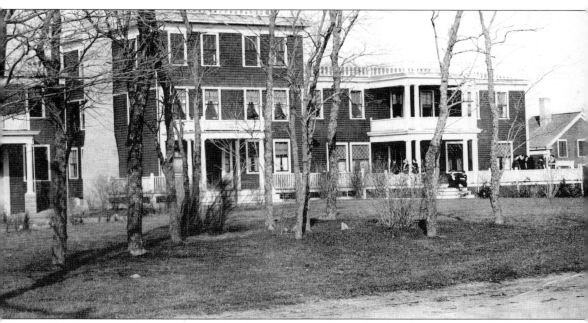

setting of pine woods stretching to the shore, this excellent school and summer camp offered every activity, homey amenities, and an impressive curriculum that any parent would wish for a child.

THE SEA PINES SCHOOL OF PERSONALITY. "Dear God, help these girls to appreciate what they possess, that they may not be satisfied in being just average persons." —Rev. Thomas Bickford's prayer. This photograph shows the Class of 1917.

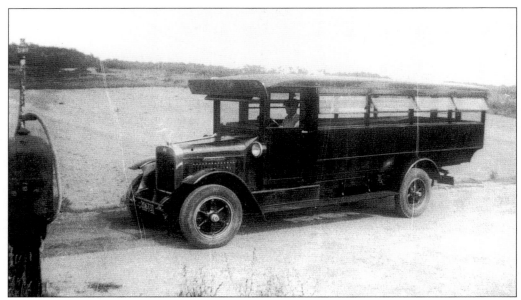

RAYMON TUBMAN. One of 10 children, farmer Raymon Tubman lived on Tubman Road in Brewster. He and his brother Myron served in World War I. Raymon Tubman was involved in the production of cranberries and also drove this school bus. (Courtesy of Sanford Tubman.)

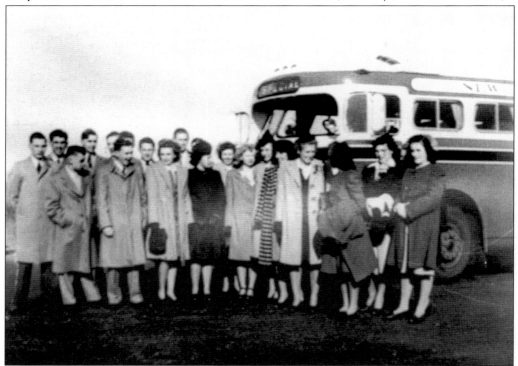

THE ANNUAL SENIOR CLASS TRIP TO WASHINGTON, D.C. The class trip, one of the highlights of the year, was sponsored by the parents and townspeople who put on plays, suppers, and card parties to raise the money. They furnished much of the winter's entertainment for the town.

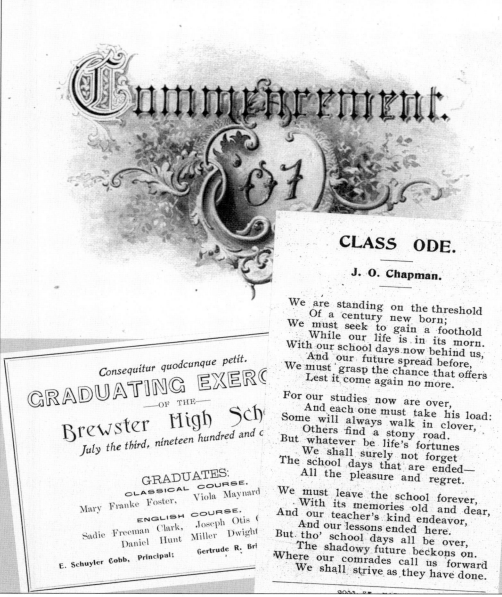

Commencement.
'01

CLASS ODE.

J. O. Chapman.

We are standing on the threshold
 Of a century new born;
We must seek to gain a foothold
 While our life is in its morn.
With our school days now behind us,
 And our future spread before,
We must grasp the chance that offers
 Lest it come again no more.

For our studies now are over,
 And each one must take his load:
Some will always walk in clover,
 Others find a stony road.
But whatever be life's fortunes
 We shall surely not forget
The school days that are ended—
 All the pleasure and regret.

We must leave the school forever,
 With its memories old and dear,
And our teacher's kind endeavor,
 And our lessons ended here.
But tho' school days all be over,
 The shadowy future beckons on.
Where our comrades call us forward
 We shall strive as they have done.

Consequitur quodcunque petit.

GRADUATING EXERC
—OF THE—
Brewster High Sch
July the third, nineteen hundred and c

GRADUATES:
CLASSICAL COURSE.
Mary Franke Foster, Viola Maynard

ENGLISH COURSE.
Sadie Freeman Clark, Joseph Otis (
Daniel Hunt Miller Dwight

E. Schuyler Cobb, Principal; Gertrude R. Bri

A GRADUATION PROGRAM. This little graduation program has survived over a century. It belonged to a member of the high school Class of 1901.

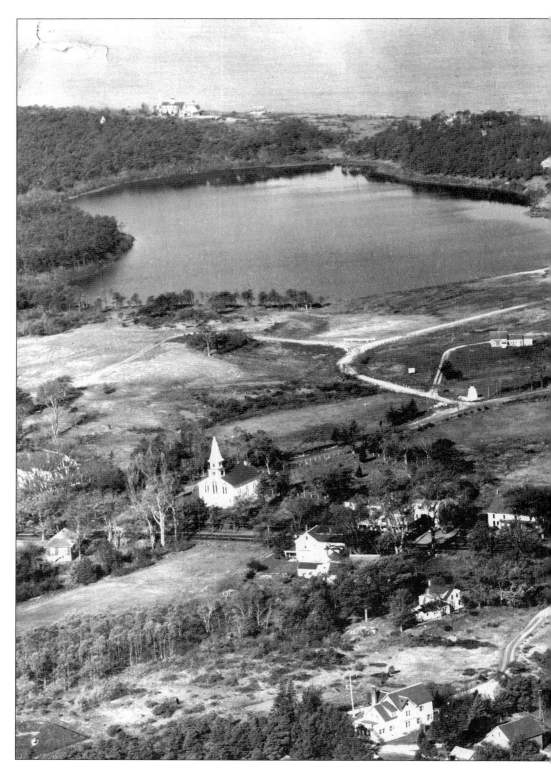

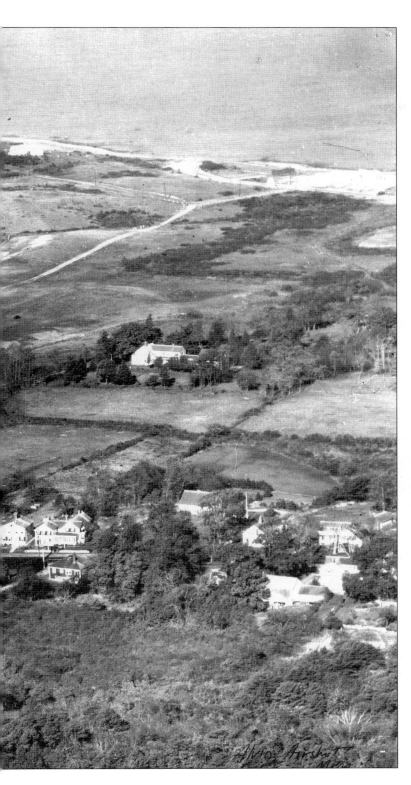

BREAKWATER ACRES. This area consists of some 60 acres, with 2,600 feet on Cobb's Pond and 1,200 feet on Cape Cod Bay. It was originally purchased by Gov. Thomas Prence of Eastham from a Native American chieftan in 1653 for 18 pounds sterling. The original name of the pond was Aquanesett. The development of the Breakwater Road area after World War II was undertaken by Warren E. Burgess of East Brewster.

45

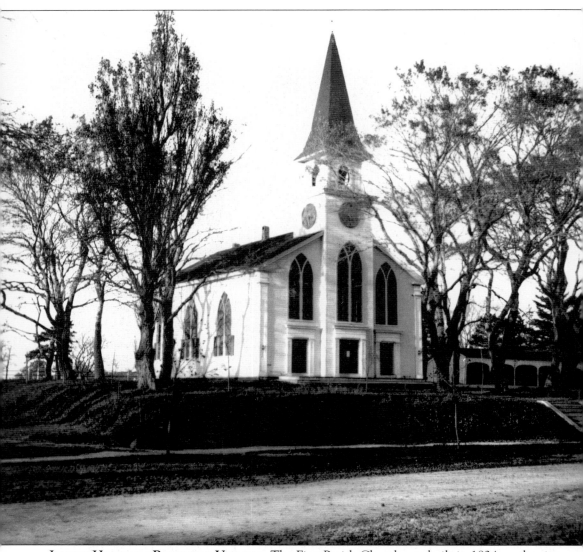

IN THE HEART OF BREWSTER VILLAGE. The First Parish Church was built in 1834 on the site of the original meetinghouse. Note the carriage buildings to the right. The clock in the church tower was given to the church by Capt. J. Henry Sears in memory of his parents.

REV. THOMAS DAWES, 1891.
Rev. Thomas Dawes served as
the minister of the First
Parish Unitarian Church from
1872 to 1904. Dawes Hall,
across the street from the
church, was named after him.
More than $1,500 was raised
to build it, and it was
completed in 1909. It now
houses Garrett Treasures, a
church-run antiques shop
staffed by volunteers.

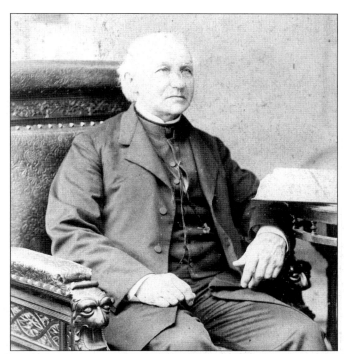

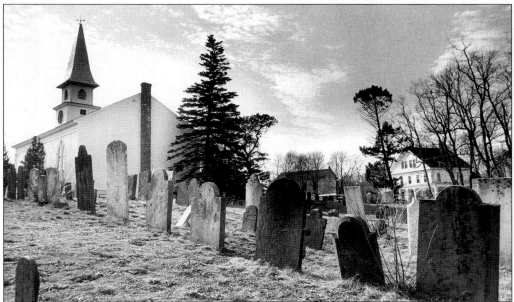

THE FIRST PARISH CHURCH OLD BURYING GROUND. This is the rear view of the church built
in 1834 on the site of the original 1700 meetinghouse. In the churchyard behind the church
are the remains of 32 officers and enlisted men who fought in the American Revolution. The
oldest stone dates from 1707, marking the resting place of Hannah Freeman. The Captain
William Freeman House is to the right in this photograph. Nearby is the gravestone of the first
preacher of the First Parish Church, Rev. Nathaniel Stone. He preached for 55 years, passing
away in 1755 at the age of 88.

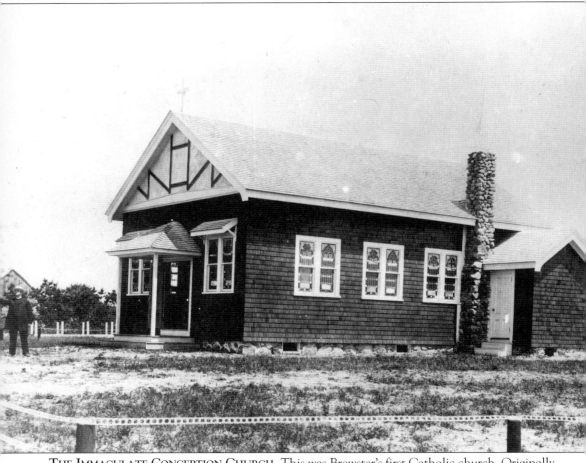

THE IMMACULATE CONCEPTION CHURCH. This was Brewster's first Catholic church. Originally, the people of Brewster were served by priests who came from Woods Hole to Sandwich, where they took a train to Harwich to say mass. In 1907, land was purchased on Main Street in East Brewster, and the little church was built by the men of the parish. Fr. George Maguire was pastor. In 1908, the first confirmation and the first wedding were held in the church.

Three

SEA CAPTAINS
AND TALL SHIPS

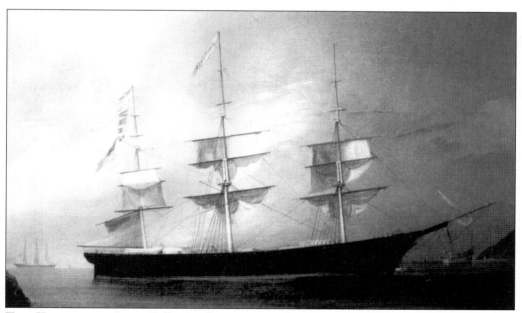

THE *KINGFISHER*. Capt. Tully Crosby, Capt. William Freeman, and many other Brewster shipmasters had command of this noble vessel. Capt. Zenas Crosby was critically injured during a voyage of the *Kingfisher* in 1853.

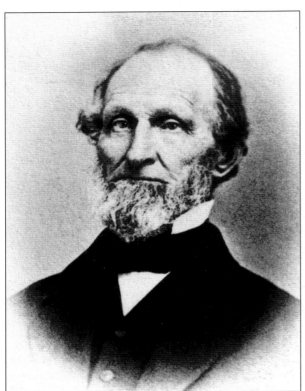

CAPT. SOLOMON FREEMAN, BORN IN BREWSTER. Capt. Solomon Freeman sailed the seas of the world. Having become financially independent at a relatively young age, he retired to his hometown. As with many former commanders of tall ships, he served several terms as a representative to the General Court and lived a long, useful life. Many of his letters from abroad have been preserved, revealing a man of great feeling and charm. His ships included the brig *Margaret* and the *Malabar*.

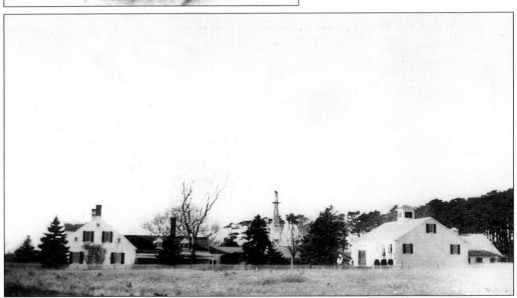

THE THORNDIKE FARM (PINECROFT FARM). Located on Lower Road, this was once the home of Brewster sea captain and prominent citizen Capt. Solomon Freeman. Augustus Thorndike owned a great many acres in the area and developed the cranberry industry on his considerable property with the help of a local farmer by the name of Fred Young. This photograph dates from the 1920s. The Eddy sisters, grandchildren of Augustus Thorndike, lived on the farm until 1955.

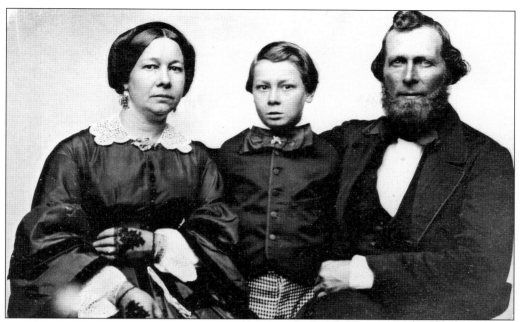

CAPT. WILLIAM FREEMAN WITH HIS WIFE AND SON. Capt. William Freeman, shown here in a daguerreotype, commanded the *Undaunted*, the *Kingfisher*, and the *Mogul*, among other ships. In 1859, some of the crew mutinied aboard the *Undaunted*, and Freeman was severely wounded. However, he prevailed and turned the mutineers over to the U.S. Consul at St. John, Nova Scotia.

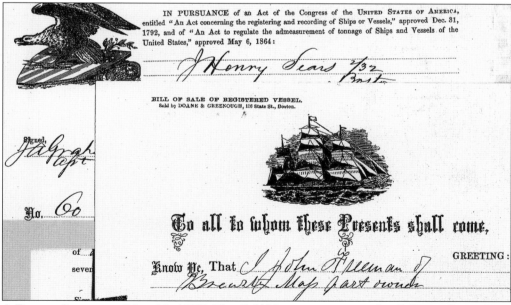

A BILL OF SALE FROM MAY 19, 1875. The *Gold Hunter* was registered to J. Henry Sears. Capt. John Freeman was one of the investors who owned a small share of the ship, which he sold to a Mr. White at South Yarmouth. The history of the *Gold Hunter* is as exciting as its name. Built in 1867, it made many voyages around the world. Its final trip in 1878 ended when it struck a coral reef during a storm on the China Sea.

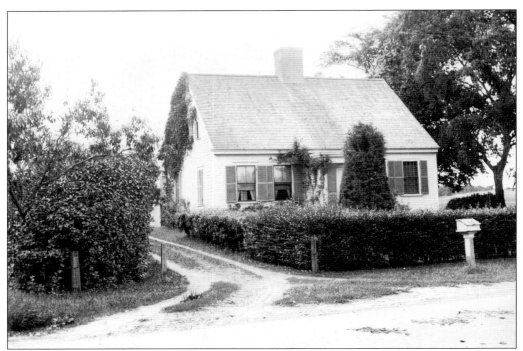

THE CAPTAIN BAILEY FOSTER HOUSE, OPPOSITE THE OLD TOWN HALL. Capt. Bailey Foster had command of the ship *Santa Claus* for several years. Born on September 9, 1809, he lived until June 1892.

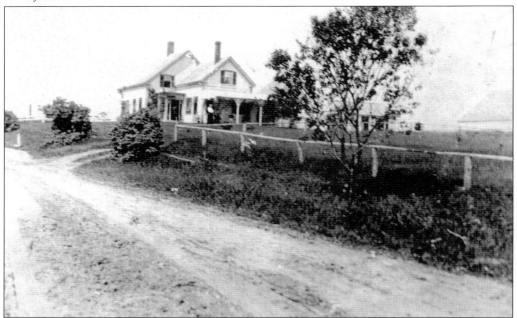

THE CAPTAIN JONATHAN FOSTER HOUSE. This house was built c. 1828 on County Road (now called Stony Brook Road) at a time of American maritime prominence when many of its sea captains called Brewster home. This photograph was taken c. 1900.

CAPT. ELIJAH COBB. Born in poverty on July 4, 1768, Elijah Cobb was put out to work as a young child by his widowed mother. Like many a Brewster boy, however, he had a dream of going to sea to make his fortune. He accomplished all this and more. During his retirement, he wrote a journal of his voyages. One trip in particular took him to France at the height of the French Revolution. The journal was published by Yale University, securing his reputation as an American shipmaster of the first rank—a man of courage and idealism.

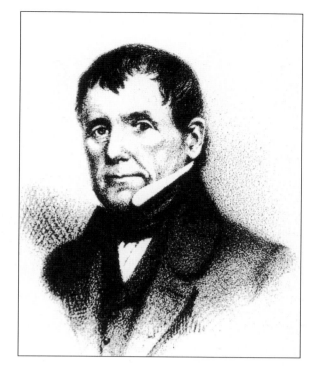

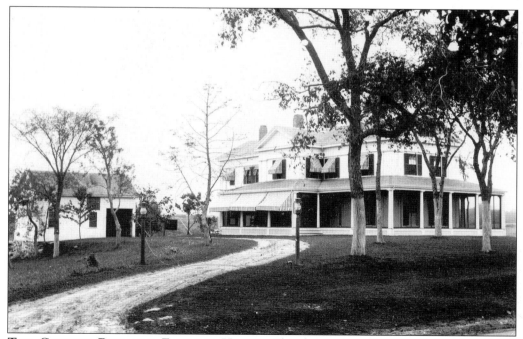

THE CAPTAIN BENJAMIN FREEMAN HOUSE. This house is a fine example of a Greek Revival–style structure on a grand scale. Capt. Benjamin Freeman commanded the *Ellen Brooks*, *Coromodel*, *Scargo*, *Climax*, and several other ships.

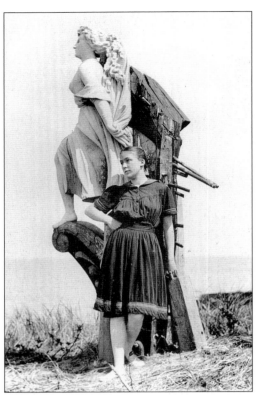

THE WHITE LADY WITH ANOTHER LADY. The figurehead called *The White Lady* belonged to Capt. J. Henry Sears, who had added it to the bow of one of his ships, the *Imperial,* in 1876. When he discovered the ship lying wrecked many years later, he saved *The White Lady* and brought it back to Brewster. It stood proudly facing the sea on the bluff near his private clubhouse. When vandals began using it for target practice, Sears's granddaughter gave it to the Provincetown Museum. (Courtesy of the Brewster Ladies Library.)

THE CAPTAIN CHARLES MYRICK HOUSE AND BARN, C. 1870. Born in 1841, Capt. Charles Myrick was master of the brig *Red Wing,* the barque *Amazon,* and several other ships sailing chiefly in the coffee trade between Baltimore and Rio de Janeiro. Although his ship *Red Wing* was lost in a hurricane, the captain and his crew survived.

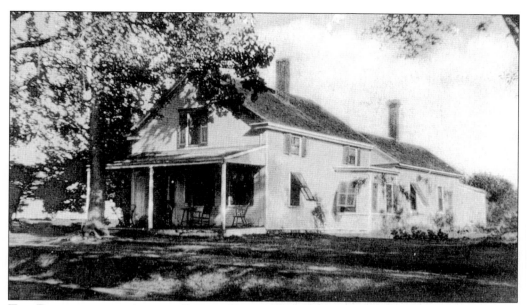

THE BIRTHPLACE OF AUTHOR JOSEPH CROSBY LINCOLN. A great many changes have been made, both inside and out, but this homestead of Brewster's prolific and most famous author and poet is still recognizable. It is cherished by his readers and generations of townspeople who, when they think about it, must be glad that a way of life that has completely vanished lives on in his books.

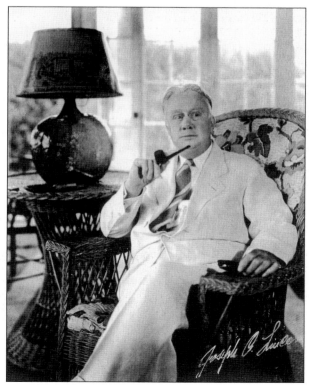

JOSEPH LINCOLN, "POET AND YARN SPINNER." Joseph Lincoln was born in Brewster on February 13, 1870. His father was a sea captain who died aboard ship in the harbor of Charlestown, South Carolina, when Joseph was less than a year old. Joseph grew up listening to the tall tales of the elderly retired mariners, which greatly influenced his life. He also heard the stories told by his adoring mother, who had made many voyages with her husband before he was born. He had a carefree, happy childhood and enjoyed close relationships with his immediate family and his grandparents.

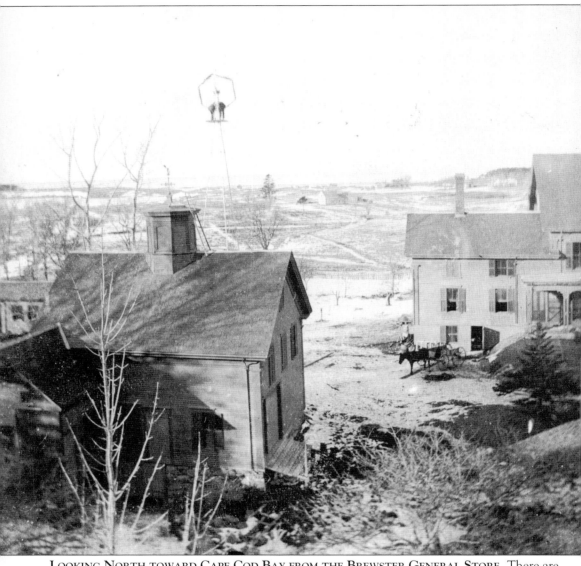

LOOKING NORTH TOWARD CAPE COD BAY FROM THE BREWSTER GENERAL STORE. There are barely any trees in this view—just a house (Captain Weatherbee's) in the distance toward Breakwater Beach. To the right is the rear of the Captain William Freeman House and, in the foreground, a barn belonging to the Freeman Cobb property. Although the Cobb mansion is gone, the barn still remains on its original site.

Capt. J. Henry Sears and His Wife. This picture is dated 1900, six years before Sears's book *Brewster Shipmasters* was published. It is still the best, most complete history of the legendary men who sailed to every corner of the earth, bringing home with them the romantic, soul-stirring stories that have flavored the life of the town down to the present age. Sears was very successful in business and most generous in his contributions to Brewster—a man of vision and a leader.

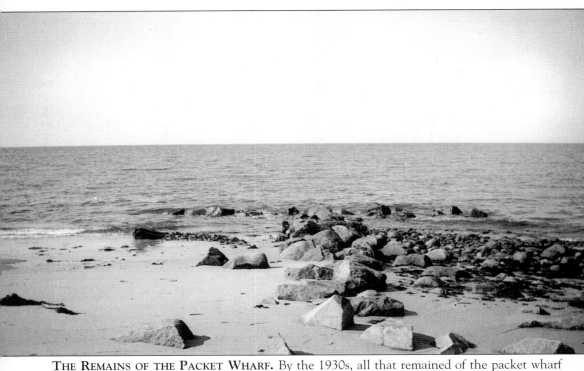

THE REMAINS OF THE PACKET WHARF. By the 1930s, all that remained of the packet wharf were these stones and timber fragments, which were visible as the tide ebbed. However, the area seems to echo with the shouts of the eager drivers and the sounds of their horses and wagons, teams of oxen and wagons, and excited children and families who were embarking for Boston and the world beyond.

Four

RECREATION AND
THE SOCIAL SCENE

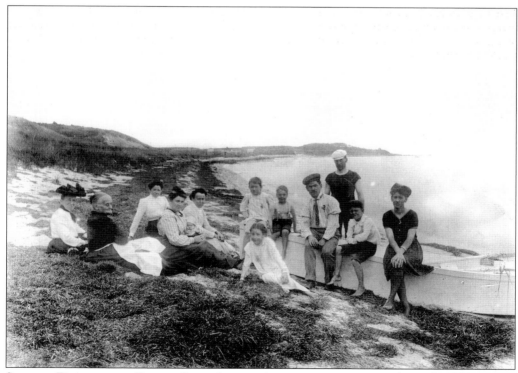

SUMMER DAYS AT THE BEACH. Several generations enjoy an outing in the early 1900s.

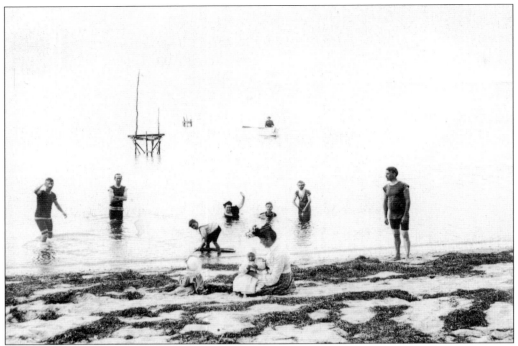

BATHERS IN TURN-OF-THE-CENTURY ATTIRE. Bathers frolic at low tide with the ever-present seaweed. In the background, a local fisherman sees to his weir. You can just see the poles sticking out of the water.

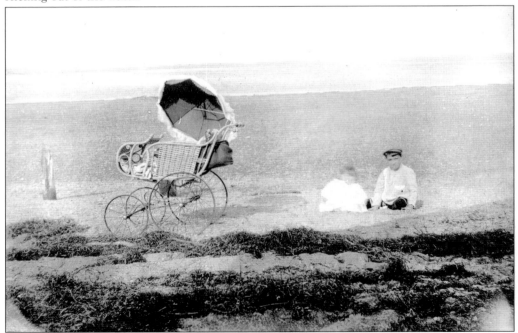

A BREWSTER BABY'S BUGGY PARKED ON THE SHORELINE. The tidal flats stretch for miles to the horizon.

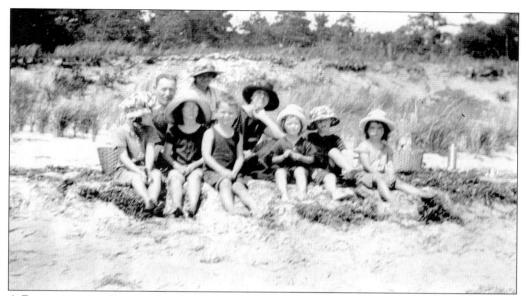

A Picnic at the Old Town Beach at the End of Breakwater Road. Mary Louise Eddy (third from right) and Jean Eddy (second from right) never tired of the beach. Pretty hats were a must. (Courtesy of Ruth Eddy.)

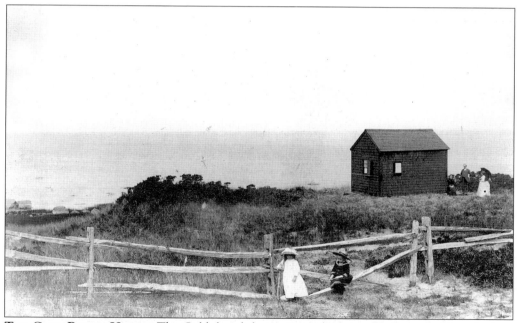

The Cobb Beach House. The Cobb beach house is perched on a bluff overlooking the bay, off Lower Road (Lobster Lane). When this photograph was taken in 1887, it was the fashion to go to the beach fully dressed, change into bathing costume in the beach house, and then enter the water. Coming out, the procedure was reversed.

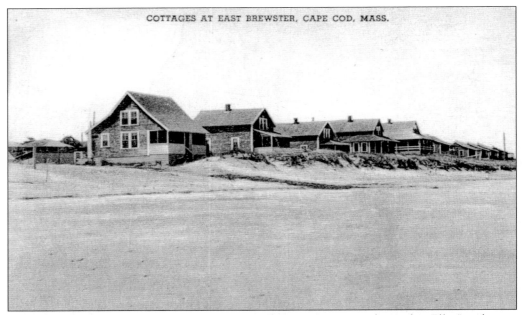

COTTAGES AT EAST BREWSTER, CAPE COD, MASS.

SUMMER RENTAL COTTAGES ON THE SHORE. These cottages were located at Ellis Landing in East Brewster.

THE EDDY SISTERS WITH A FRIEND (LEFT). This photograph was taken at a Brewster beach off Lower Road. (Courtesy of Ruth Eddy.)

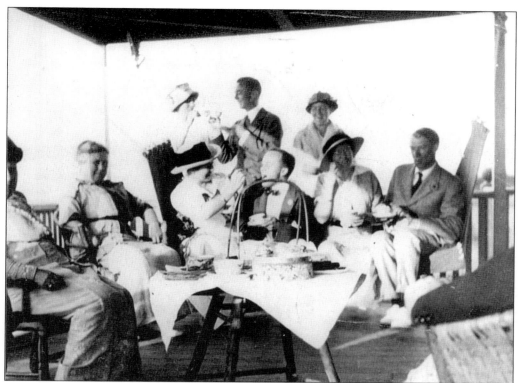

A Party at the Sears Clubhouse. To the right are Clifford and Louise Eddy, owners of Pinecroft Farm next door. The clubhouse was part of the first golf course in Brewster. (Courtesy of Ruth Eddy.)

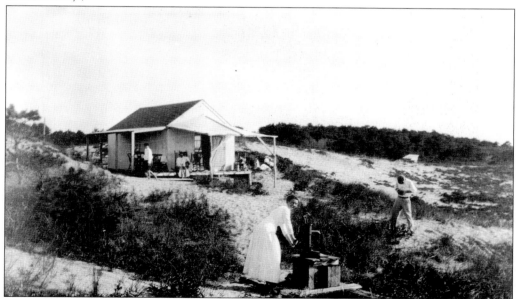

By the Sea, by the Sea. Shown is a typical summer cottage scene overlooking Cape Cod Bay. The woman and man are posing for photographer Caro Dugan.

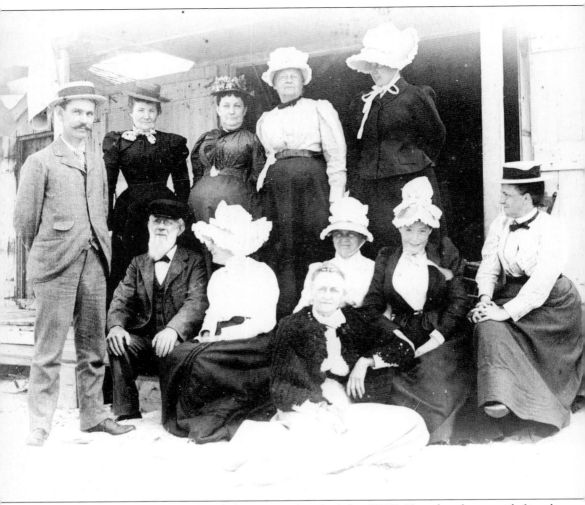

AT A BEACH HOUSE. The bearded man seated to the left is W.W. Knowles, shown with friends.

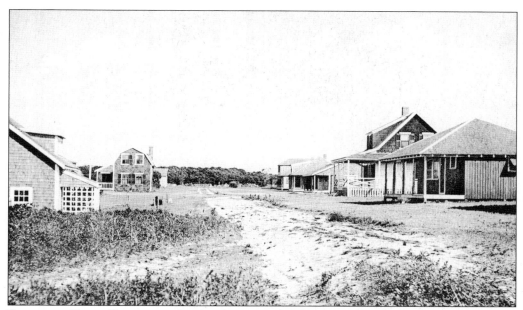

BREWSTER PARK COTTAGES. Surely, this is one of the most cherished spots in Brewster, a private community of cottages that has grown over the years since 1906, "family by family." Although it has changed somewhat, it has never lost its simple charm nor the lure of its closeness to the imperishable sea beyond its shore.

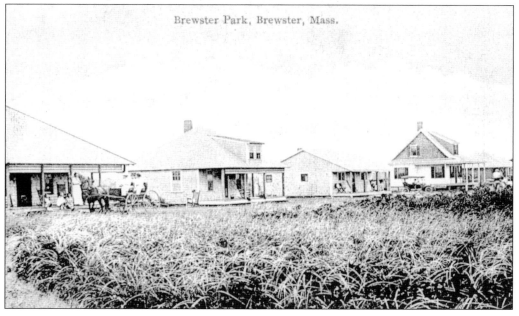

Brewster Park, Brewster, Mass.

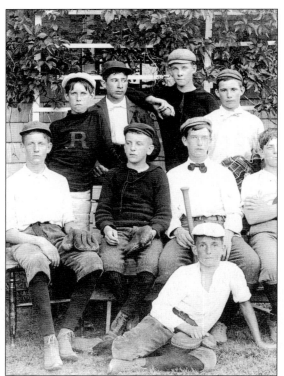

AN EARLY BREWSTER BASEBALL TEAM. Sitting on the ground in the front is Arthur Crowell. The others are, from left to right, as follows: (front row) Maurice Lee, Waldo Allen, Ernest Doane, and Henry Briggs; (back row) Irving Eldridge, John Brier, Willis Clark, and unidentified.

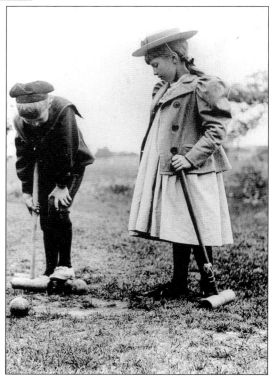

MADELINE COBB. Madeline Cobb has finally met her match at croquet. (Courtesy of the Brewster Ladies Library.)

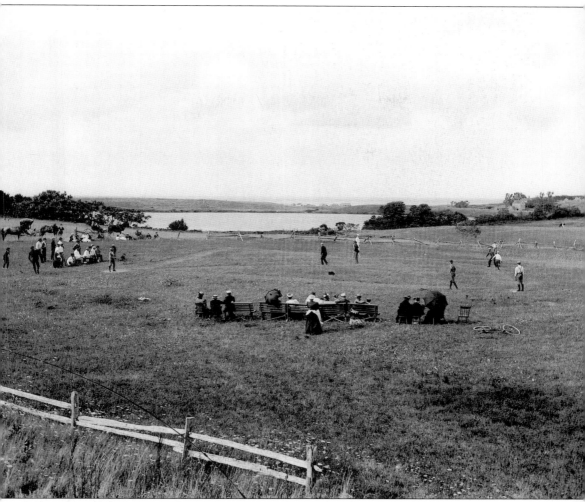

A BASEBALL GAME IN THE COBB FIELDS. An entranced audience of local supporters watches the game.

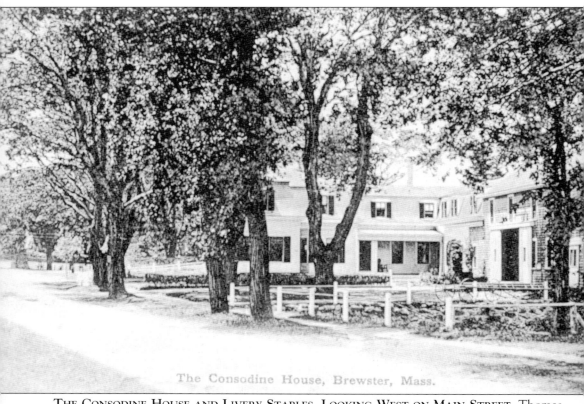

The Consodine House, Brewster, Mass.

THE CONSODINE HOUSE AND LIVERY STABLES, LOOKING WEST ON MAIN STREET. Thomas Patrick Consodine and his wife, Clara, were the original proprietors of the livery. When Thomas died in 1920, his brother John took part in the running of the business. In this photograph, Main Street is still unpaved.

JOHN CONSODINE. John Consodine looks straight at the camera after a trip to the cottages on the bluff above Brewster's beach, probably Brewster Park.

THOMAS CONSODINE. Consodine is seen here posing with a friend. Centrally located within half a mile of the train station, the livery stable was a great convenience for locals and visitors right up until the automobile became popular.

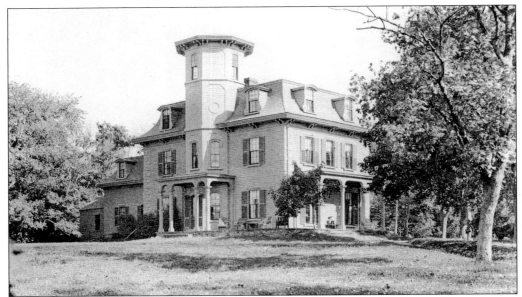

FREEMAN COBB'S HOUSE, ONE OF THE GRANDEST HOMES IN TOWN. This house was built in 1857 with the fortune that Freeman Cobb made in Australia. He took supplies and passengers to the newly discovered Australian gold fields in Concord coaches, which were built in New Hampshire. They were ideally suited to the nearly impossible terrain and desperate conditions of the Outback. So crucial was his operation to the success of Australia's gold rush that to this day the name Cobb is held in high esteem in that distant continent.

THE CONCORD COACH. This etching by Lionel Lindsay depicts one of Cobb and Company's coaches racing across the Australian Outback. The coaching line was established by Freeman Cobb in 1853. (Gift of Esther L. Holt.)

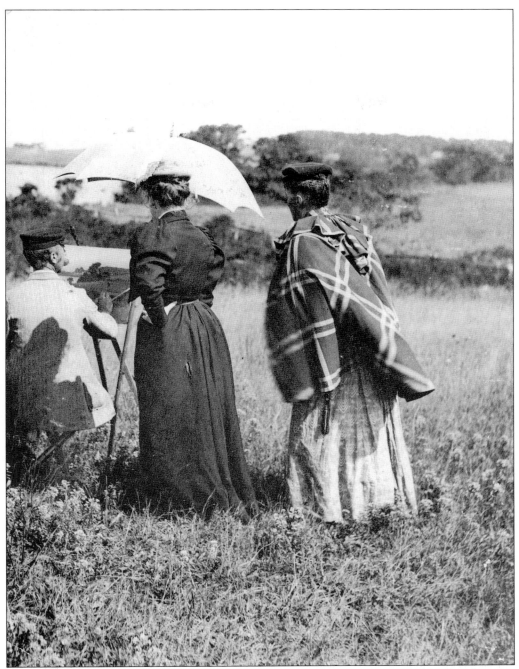

AN ARTISTIC EXCURSION. In September 1894, L. Earle paints a view of Cobb's Pond from a field of wildflowers. He is accompanied by his wife and her companion, both of whom are no doubt encouraging in their appreciation of his efforts. The pond was a well-loved destination for walkers and children at all times of the year. It was part of the Capt. Elijah Cobb estate on Lower Road, one of the best-known properties in Brewster. The woman in the bright plaid cloak is Emily C. Cobb, daughter of Elijah Cobb Jr.

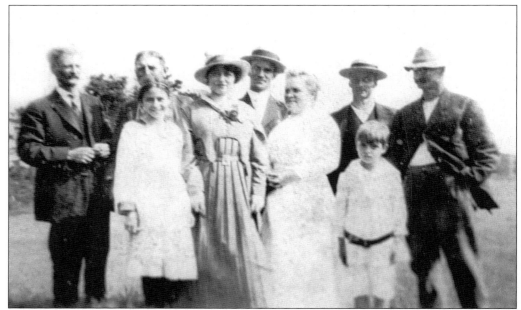

THE FOSTER FAMILY. Some of the descendants of Chillingsworth Foster are shown in 1905.

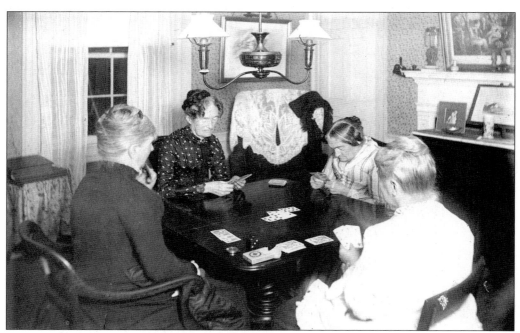

PLAYING WHIST AT THE CAPTAIN ELIJAH COBB HOUSE. These women would play whist during the evenings. At the first stroke of 10:00, however, the cards were thrown down. Caro Dugan lived in this house and recorded with her camera nearly every aspect of life in the town.

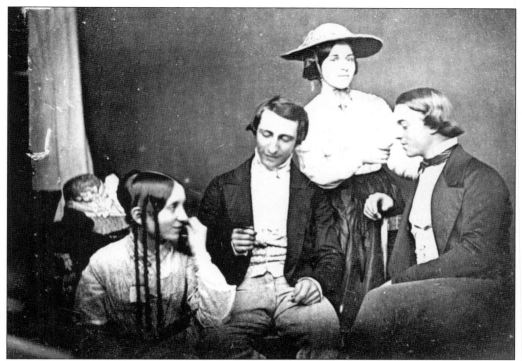

Lucy Thatcher, Winslow Cobb, Helen Cobb, and Henry Sears. This daguerreotype speaks for itself—young people enjoying themselves in their finery. (Courtesy of the Brewster Ladies Library.)

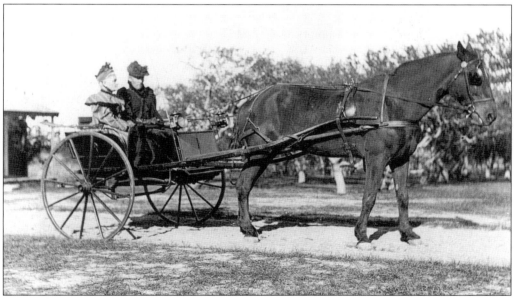

A Morning Drive. Taking a drive seems to be a pleasure for these two prominent Brewster neighbors—Mrs. Helen Dugan and Mrs. Freeman Cobb. (Courtesy of the Brewster Ladies Library.)

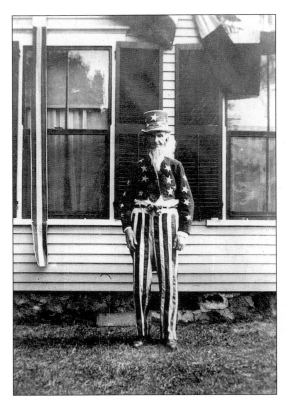

CPL. JOHN J. RYDER. Born in Brewster in 1843, Cpl. John J. Ryder holds the distinction of being the first volunteer in the Union's cause from the town of Brewster. He appeared in patriotic dress for many years to help celebrate national holidays and enjoyed a long and very active life. His book *Reminiscences of Three Years Service in the Civil War* was published in 1928.

ADUAH ROGERS. Like many of his contemporaries, Aduah Rogers went to sea as a young man, but his heart was firmly attached to a young woman back home in Brewster, Mary Atwood Higgins. He expressed his true feelings in a token of his love, a whalebone busk delicately decorated over every inch of its surface with poetry, trees, flowers, designs, and even his ship. It is now part of the Brewster Historical Society collection, along with many family papers and pictures. It is known that the couple, who married in 1846, settled in East Brewster. Aduah Rogers became a harness maker.

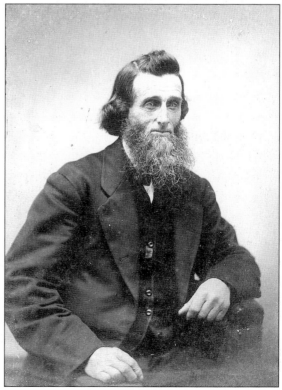

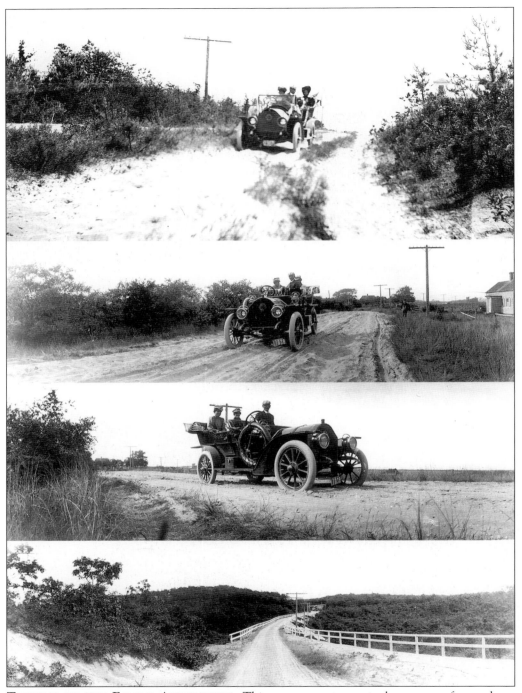

TOURING IN THE FAMILY AUTOMOBILE. This was a great way to have some fun and see something of the Cape. Intestinal fortitude helped because the roads were bad.

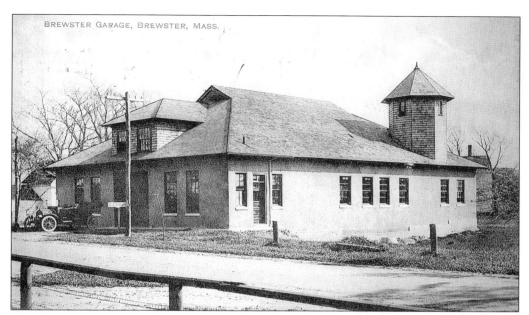

BREWSTER GARAGE, BREWSTER, MASS.

THE BREWSTER GARAGE. This garage was located on the corner of Depot Road and Route 6A, opposite the old town hall. It was built *c.* 1910 out of concrete blocks to accommodate the automobiles of that era. People often inquire about the shingled tower, but no one knows why it was built.

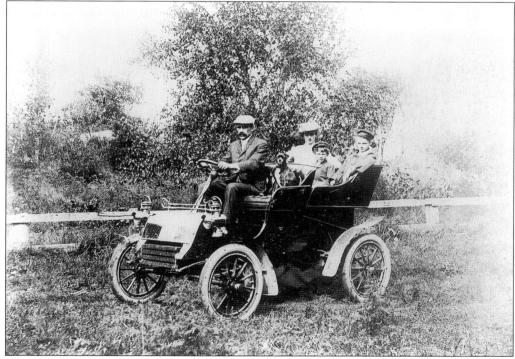

A FAMILY OUTING. These people are dressed in their best Sunday finery with a well-behaved dog in front.

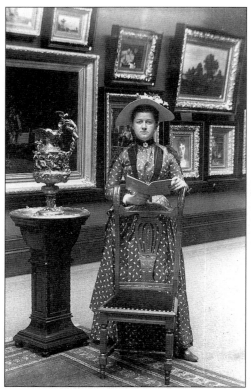

MATILDA CROSBY. The second wife of Albert Crosby, Matilda Crosby was the woman for whom he built Tawasentha, their beautiful Colonial Revival–style mansion that overlooked the bay. She is shown in the much publicized art gallery.

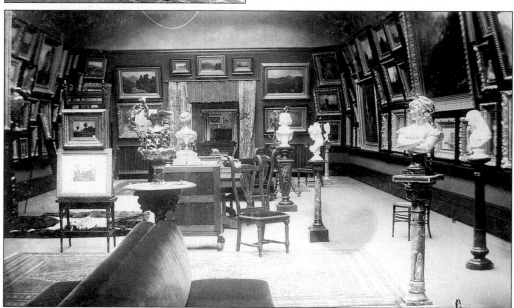

THE CROSBY ART COLLECTION. The Crosby collection was housed in a fireproof, windowless gallery attached to the mansion. The public was invited "to see the pictures" one day a week. The entire building was lit with gas lamps. Although there were no gas lines in Brewster when the house was built in 1888, gas was manufactured in the basement.

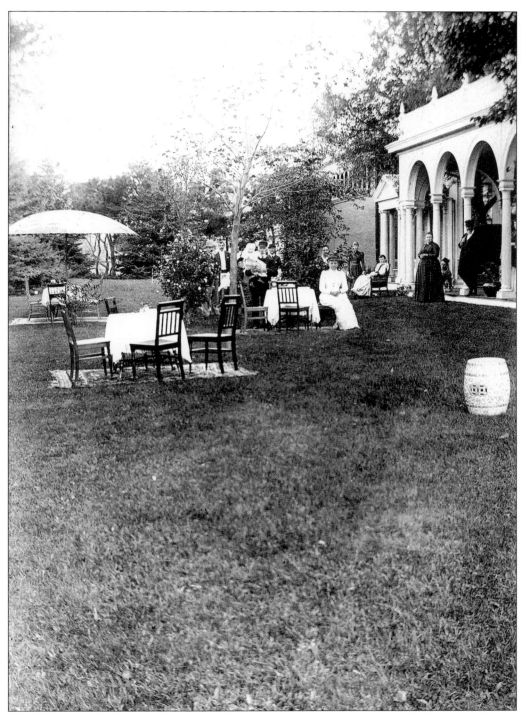

TEA TIME AT THE CROSBY MANSION. Tea was served in grand style on the lawn, much as it was done in England at that time. In the background is a glimpse of a brick building, which was the art gallery where the Crosbys displayed their vast collection.

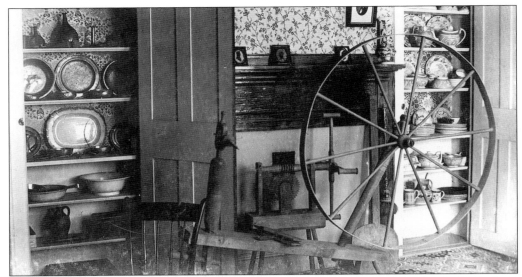

THE OLD SPINNING WHEEL. This wheel dominates the parlor of the Albert Crosby birthplace, which has been carefully restored and decorated in this photograph from the Crosby Mansion Collection. The mansion, called Tawasentha by owners Albert and Matilda Crosby, was named fondly after a line in "Hiawatha," by Henry Wadsworth Longfellow. The Crosbys decided to build a summer house on the very site of the place where he was born, surrounding his ancestral home, with a secret door connecting the two. During parties, Albert often slipped away through the mystery doorway in the entrance hall. Donning his slippers and smoking jacket, he puffed on his cigar in this very room. To the left of the fireplace is a fine collection of glass, pewter, stoneware, and English Leedsware. To the right is a typical collectors cupboard filled with English Staffordshire and Chinese export mugs.

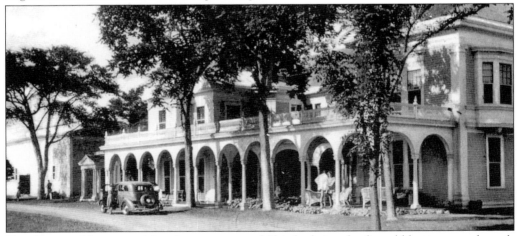

THE CROSBY MANSION. After the estate was sold by the heirs, the fine old house went through several transformations. It housed the Cape Cod Institute of Music, founded in 1936 by Martha Atwood Baker. It was also a much admired restaurant called the Gold Coast and, in more recent times, a sailing camp for girls. All of the rare paintings and sculptures were sold for a mere fraction of their worth. However, the excellent craftsmanship that went into the house itself—stained-glass windows, elegant fireplaces, superb wallpapers, moldings, and lighting fixtures—survived. Even now, some of the glory remains. Today, it is part of Nickerson State Park.

THE OLD TOWN HALL. Built in 1881 for $10,000, the old town hall was designed in the popular Queen Anne style by Walter T. Winslow. This early photograph shows the unusual roof of the tower atop two fragile supports. When this picture was taken, the porte-cochere was used to allow horse-drawn vehicles to bring visitors directly to the front doors, protecting them from the weather. Sometime later, the driveway was filled in and made into a raised porch. When the town hall opened, the governor came to Brewster and addressed an enthusiastic crowd. The Germania Band of Boston played during the day and evening ceremonies, which included a huge banquet followed by dancing. The town hall is one of the few 19th-century public buildings on the Cape to survive. It is now occupied by the Council on Aging, serving senior citizens as a center for their activities.

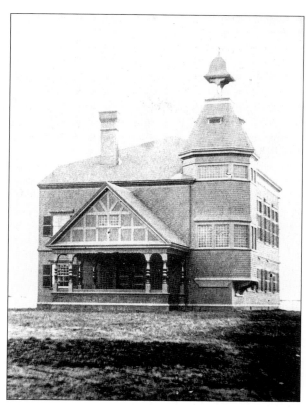

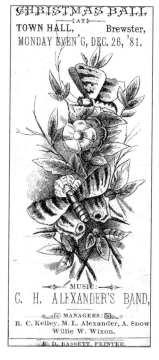

A TICKET FOR THE CHRISTMAS BALL. This ball was held at the new town hall.

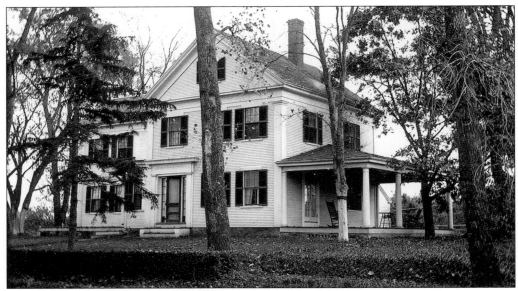

THE ELM TREE INN. Cordelia Keith and her family moved to Brewster in 1901. Descended from Capt. Solomon Freeman, she recalled her father farming the land belonging to the Charles Freeman House, a grand Greek Revival structure sitting squarely opposite the First Parish Unitarian Church on Main Street. He kept a horse that had belonged to the local doctor. It would stop at each former patient's house automatically. Eventually, Cordelia Keith became an innkeeper. She called the place Funcroft, principally catering children's parties. Later, she took in guests and renamed the house the Elm Tree Inn. She held court for a loyal following of visitors for nearly 40 years. They became close friends, and the inn was one of the most beloved in all of Brewster. Filled with beautiful antiques and family portraits, fresh flowers, and delicious aromas from the homey kitchen, a visit to the inn was a treat never to be forgotten.

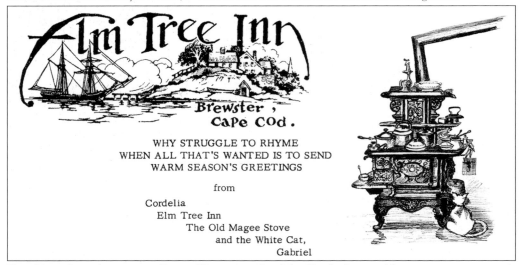

ELM TREE INN ARTWORK. Every Christmas, Cordelia Keith designed her own greeting cards and stationery to keep her valued customers at the Elm Tree Inn apprised of her appreciation for their continued patronage. She was a gifted and highly original sketch artist who kept everyone amused and delighted with her poems, letters, and drawings.

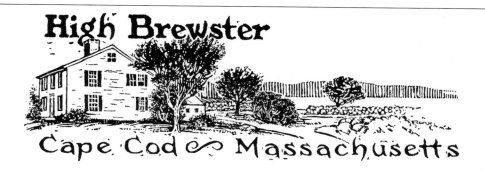

High Brewster

Cape Cod & Massachusetts

"And hie him home, at evening's close,

To sweet repast and calm repose."

(Gray)

FRANK AND MARY CLEVERLEY
HIGH BREWSTER
BREWSTER, MASS.
TEL. BREWSTER 59

HIGH BREWSTER. Once the home of Nathaniel Winslow, High Brewster had the great advantage of location. Besides being a fine-looking house, it had a beautiful view of the Lower Mill Pond and lush scenery sweeping down the Stony Brook valley to Cape Cod Bay. It descended in the Winslow family to Mary Cleverley and her husband, Frank. They operated the house as an inn and established an outstanding reputation. It was recently sold as a private home to a new family, thus beginning a new tradition.

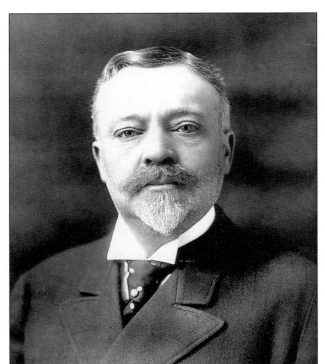

ROLAND CROSBY NICKERSON.
Born in 1859, Roland Crosby
Nickerson was very active in
civic affairs, serving on the
Governor's Council of
Massachusetts. The photograph
was taken a year before his death
in 1906. (Courtesy of Mrs.
Samuel Nickerson.)

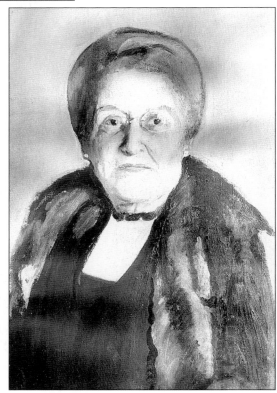

ADDIE DANIELS NICKERSON. Addie
Daniels Nickerson and her husband,
Roland, had a house in Chicago, but they
spent most of their time in Brewster.
They had three children—Roland,
Samuel, and Helen. (Courtesy of Mrs.
Samuel Nickerson.)

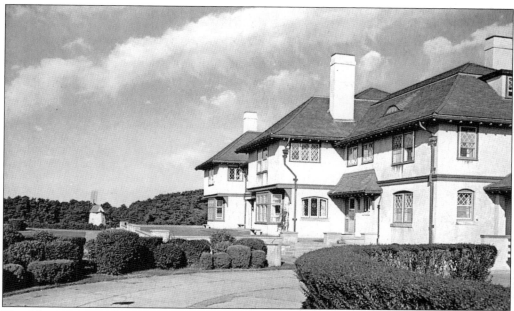

THE NICKERSON MANSION. This view of the Nickerson mansion is interesting because is shows the Higgins Farm Windmill on the estate when it was used as the clubhouse for the family's private golf course. When it was presented to the Brewster Historical Society in 1974 by Mrs. Samuel Nickerson, the top was removed and the entire windmill was moved down Route 6A on a flatbed truck to its present location. It now sits on its permanent site belonging to the Brewster Historical Society just to the west of the Drummer Boy Park Grounds.

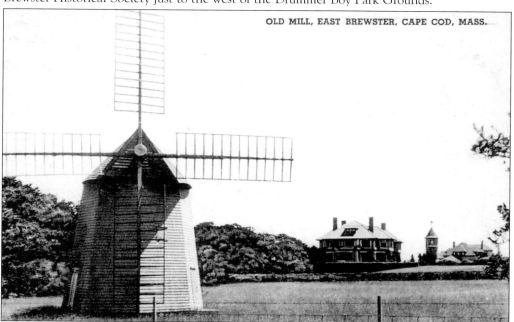

OLD MILL, EAST BREWSTER, CAPE COD, MASS.

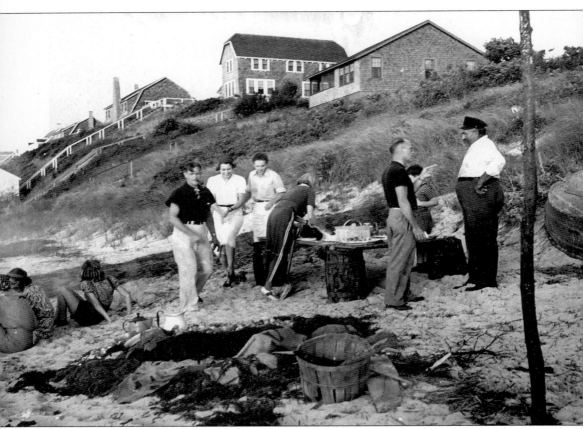

FRED YOUNG. Well known for his skills as a farmer and carpenter, Fred Young was also famous for his clambakes. Every year on July 25, all the guests of High Brewster, friends of the Cleverleys, and all of the actors at the Dennis Playhouse were invited by the Cleverleys' to a clambake on the shore.

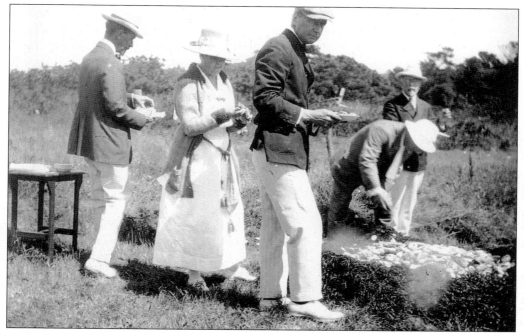

A TRADITIONAL PASTIME, THEN AS NOW. This clambake is replete with heaps of seaweed and the proper amount of steam. Participants are boasting some snappy blazers and whites, everything as it should have been on a perfect August day. (Courtesy of Ruth Eddy.)

A SUMMER PICNIC ON THE GRASS, 1918. This photograph shows the view all the way to Provincetown. People dressed up for picnics in those lovely bygone days.

BRAD AND KAY CLARK'S CLASSIC CAPE HOUSE ON STONY BROOK ROAD. Brad and Kay Clark met at High Brewster. Brad was kind and amusing, loved antiques, and knew all about them. Kay was a gifted designer, and together they made magic at the Packet Antiques Shop, their business next door to the house.

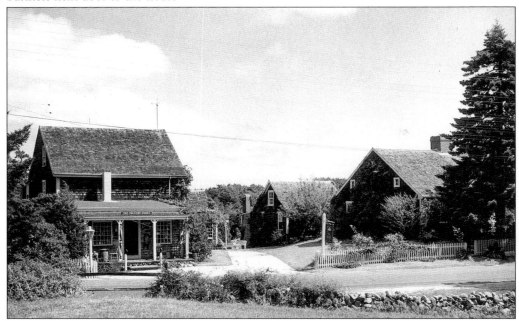

THE PACKET COUNTRY STORE. Originally a barn on the Clark property, this was a favorite Brewster landmark for antiquing.

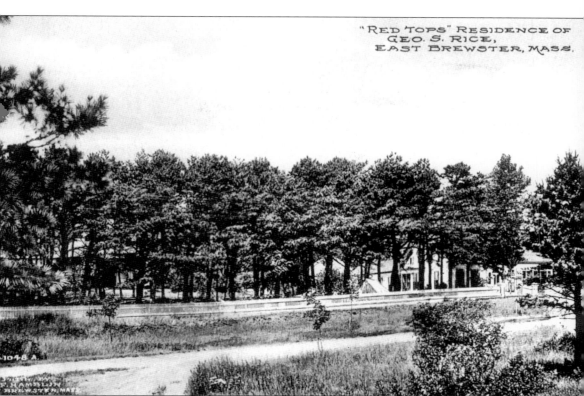

"RED TOPS" RESIDENCE OF
GEO. S. RICE,
EAST BREWSTER, MASS.

RED TOPS, MAIN STREET, EAST BREWSTER. Red Tops, so named because of the red-stained roof, fell into disrepair until it was purchased by the state. It eventually became the headquarters of the Cape Cod Repertory Theatre.

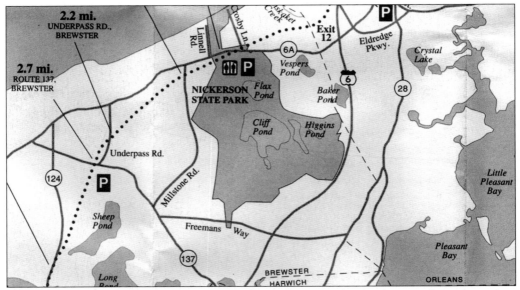

NICKERSON STATE PARK. The first in Massachusetts, this park provides outstanding recreational facilities to the public. Roland Crosby Nickerson Sr. bought the land (1,727 acres) *c.* 1890 and created a private game preserve for his family. Many more acres around the beautiful freshwater ponds—Cliff, Little Cliff, and Flax Ponds—were acquired over the years, and a hunting lodge was built next to Flax Pond. Nickerson called it Bungalow Estate. The land was donated to the Commonwealth in 1934 by Addie Daniels Nickerson and Helen Nickerson Sears in memory of Roland C. Nickerson Sr. and Roland C. Nickerson Jr. (Reproduced with the permission of the Department of Environmental Management.)

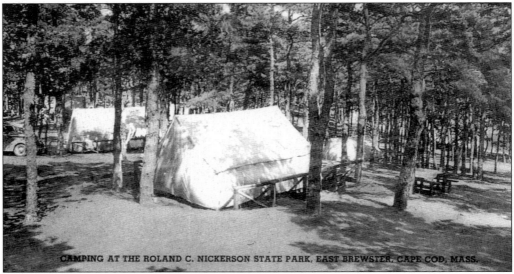

CAMPING AT THE ROLAND C. NICKERSON STATE PARK, EAST BREWSTER, CAPE COD, MASS.

A NICKERSON STATE PARK CAMPING AREA. "Currently there are more than 400 campsites. One of the biggest pastimes for more and more Americans, and camping out on Cape Cod is an interesting experience, one because the Cape is such a lovely spot, and two, because it is very hard to find a spot to camp." —The *Cape Cod Summer-Times*, August 13, 1967. There are 13 miles of hiking and bicycle trails within the park. (Courtesy of Dorothy Daley.)

90

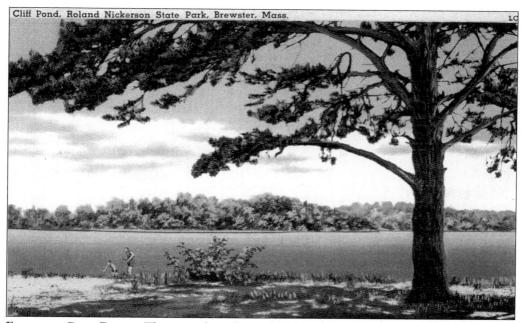

FLAX AND CLIFF PONDS. These ponds are located within the 1,961-acre Nickerson State Park. Described as kettle ponds, they were formed when the glacier icecap covering this part of the Cape receded, leaving deep holes in the ground filled with fresh water. Cliff Pond is the largest pond in the park, measuring a remarkable depth of 90 feet in one area. The ponds are stocked with trout and provide a variety of recreational pursuits for campers. There is boating, fishing, and swimming to delight visitors of all ages.

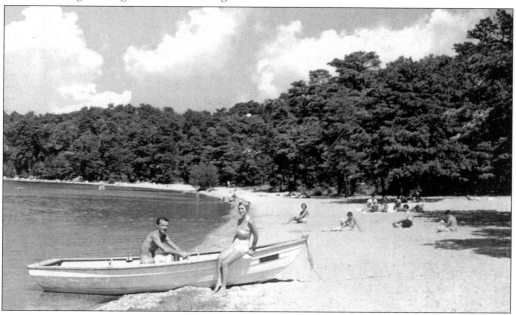

TINY SEASONAL RESTAURANTS. Seasonal restaurants specializing in fresh seafood and homemade pies were once a common feature on the Cape. Every summer visitor had his favorite and returned again and again in the family car, as in this photograph of Lee's Sea Grill.

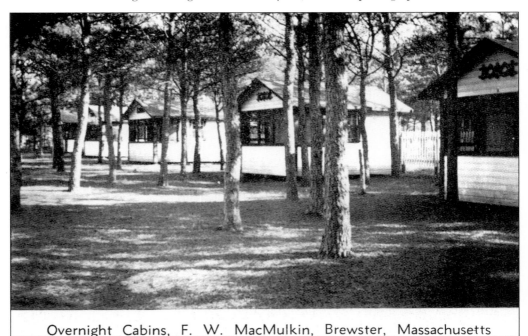

Overnight Cabins, F. W. MacMulkin, Brewster, Massachusetts

OVERNIGHT CABINS IN THE PINES. The advent of the automobile brought a new adventure to travel: the auto court or cabin. These one-room buildings meant that one could pull up to the door, unload the suitcases, and practically jump into the surf. The privacy, low cost, and convenience ensured that the cabins were here to stay—at least until after World War II, when they were gradually replaced by bed and breakfasts.

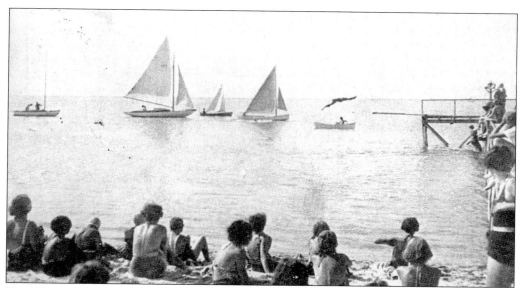

THE PERFECT SUMMER DAY IN EAST BREWSTER. The Sea Pines School also had an ambitious summer program.

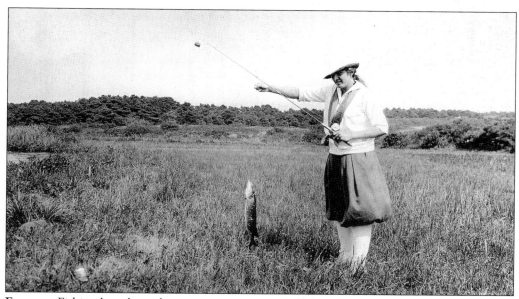

FISHING. Fishing has always been an important part of life on the Cape. In fact, before a single crop was harvested, people probably fished to stay alive. They pickled it, dried it, salted it, boiled it, fried it, and (in the case of shellfish) often ate it raw.

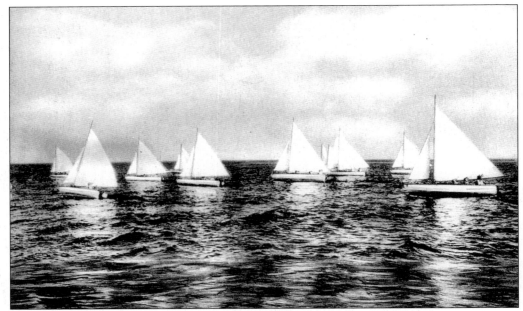

CAMP MONOMOY. A sailing camp founded in 1922 by the Delahanty family, Camp Monomoy was sold in the early 1980s to the Commonwealth of Massachusetts to be incorporated into Nickerson State Park.

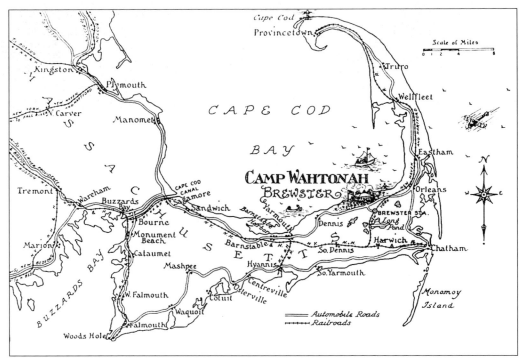

CAMP WAHTONAH. The camp helped put Brewster on the map.

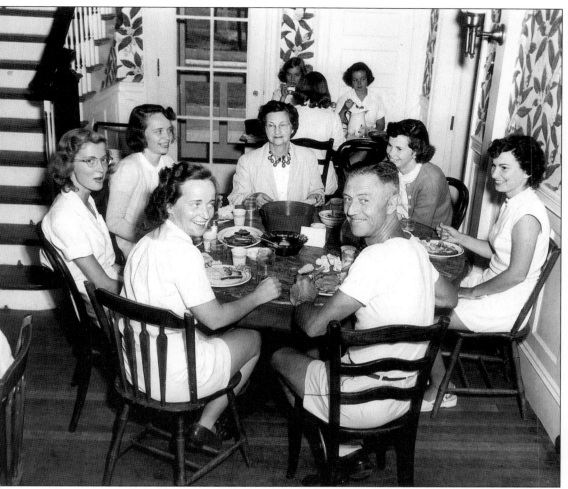

A Morning Breakfast at Camp Wono, 1948. Sitting at the table in the center is Emma Delahanty, who with her husband owned what evolved into the Cape Cod Sea Camps of today. Next to her to the left is Fran Delahanty Garren. To the right of Emma Delahanty is Berry Delahanty Richardson. (Courtesy of Mimi McConchie.)

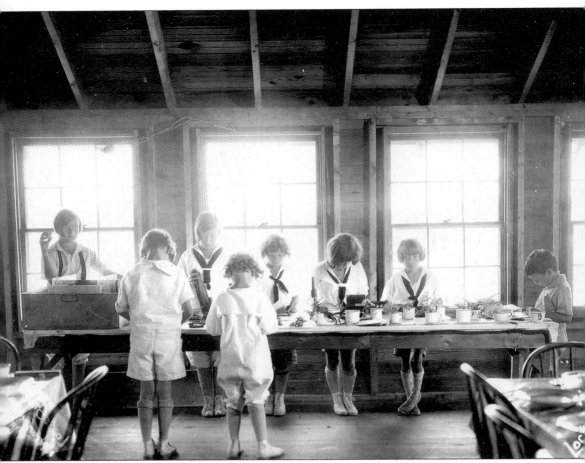

BREWSTER WAS IDEALLY SUITED FOR SUMMER CAMPING. Healthy food from nearby farms, clean salt air (considered beneficial), safe beaches, open fields, and shaded woodland paths all contributed to an idyllic environment for the young. At Camp Wahtonah, girls were encouraged to develop their creative skills. They made jewelry and baskets. They also worked on leather, batik, and woodwork and modeled in clay. Overlooking the Mill Ponds on Stony Brook Road, Camp Satucket was another splendid camp for little girls. The camp was owned and operated by A.W. Foster.

"NOW, ALL TOGETHER. . . ." Candy between meals was a definite no-no, but these girls at Camp Wahtonah are taking no chances with their teeth. Mrs. Frederick T. Burdett was the director of the camp and was devoted to her charges, who enjoyed a full array of summer activities from sailing to singing. Indeed music was a big part of the camp's program.

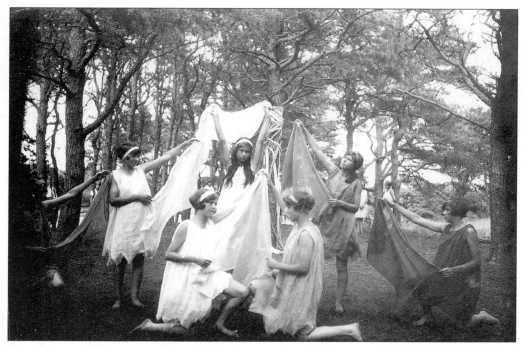

THE ANNUAL WAHTONAH PLAY. This play was given in the grove with the silvery waters of a lake as a background. The younger girls helped with the production as well. This performance was called *Maypole*.

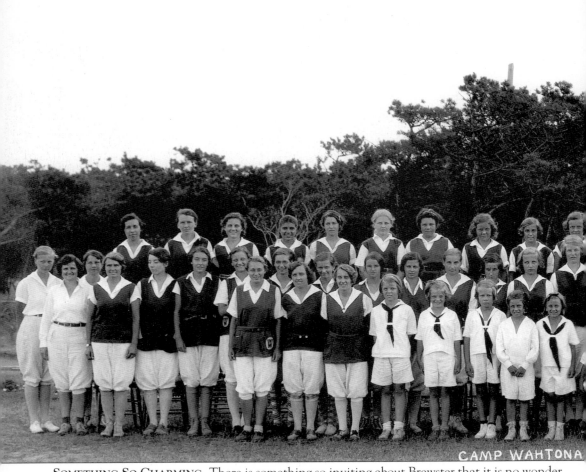

CAMP WAHTONA

SOMETHING SO CHARMING. There is something so inviting about Brewster that it is no wonder summer camps took root early in the 20th century and never entirely left. One of the most popular was Camp Wahtonah, near the village on a bluff overlooking the bay, with 1,000 feet

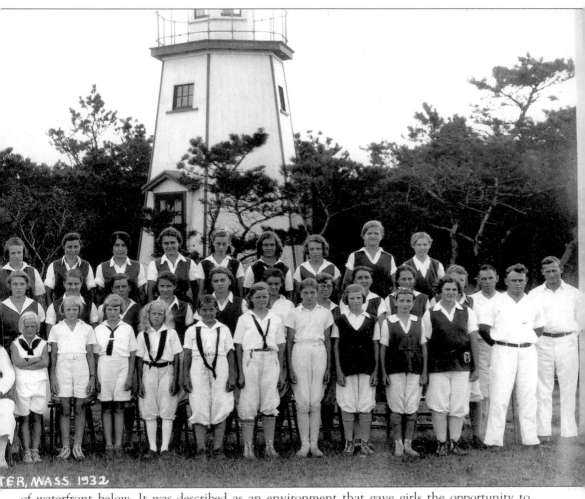

ER, MASS. 1932

of waterfront below. It was described as an environment that gave girls the opportunity to experience the joy of natural living.

THE DRUMMER BOY MUSEUM AND GIFT SHOP. If ever there were kind-hearted, friendly people in Brewster, their names must have been Tony and Bette McGowan, owners of the Drummer Boy. In 1974, the McGowans gave the Brewster Historical Society an acre and a quarter of prime green fields and woods for the new location of the Higgins Farm Windmill and the Harris-Black House, both dating from c. 1795. Then, before Tony's untimely death, he sold his home and all his property to the town at a tiny price to be paid over a period of 10 years. Because of this great, good man and his delightful, generous wife, Brewster has a beautiful park and playground and a magnificent view of the water that is unique to Brewster. The McGowans' spirit will infuse every acre, every blade of grass for all time.

100

Five

MEMORIES OF
YESTERDAY

STROLLING ALONG LOBSTER LANE. This image dates from the summer of 1887.

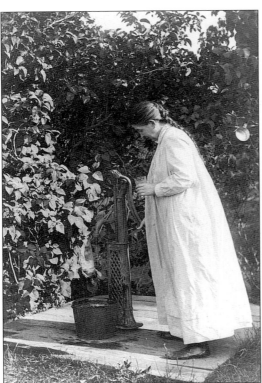

AN EARLY-MORNING DRAUGHT.
Photographer Caro Dugan particularly enjoyed capturing images of her friends doing ordinary things. (Courtesy of the Brewster Ladies Library.)

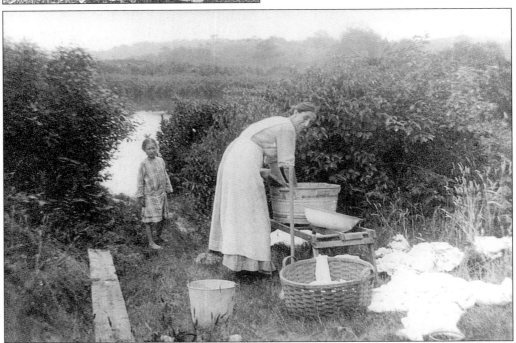

WASH DAY, C. 1918. The location is Lower Mill Pond. The clothes spread out on the ground were probably bleaching in the sun while drying. (Courtesy of Mimi McConchie.)

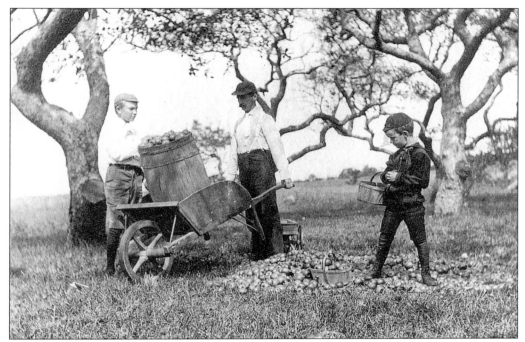

APPLE HARVESTING. Brewster residents were devoted to their orchards and, for all the woes about the wind and weather, the fruit trees were bountiful. (Courtesy of the Brewster Ladies Library.)

CHALKING THE BADMINTON COURT. A worker prepares the badminton court for summer guests at High Brewster. (Courtesy of Mimi McConchie.)

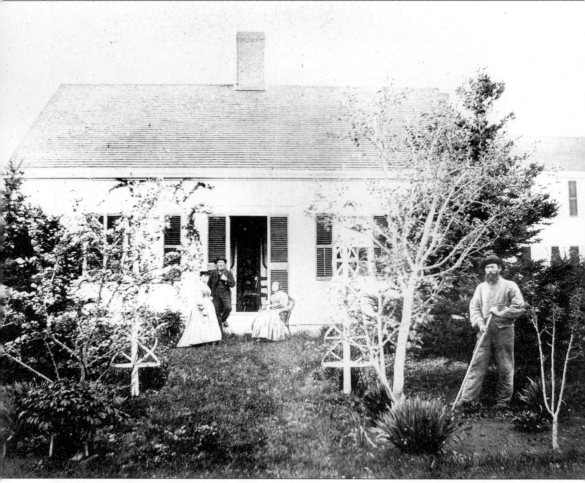

THE CROSBY HOUSE. This charming house, built *c.* 1720, survives as a private residence. With its ancient trees and sweeping lawn, it sits squarely alongside the former Nickerson estate. (Courtesy of Mrs. Samuel Nickerson.)

CHARLES CROSBY RIDING A BICYCLE.
During a remarkably long life (spent entirely in Brewster), Caro Dugan observed a great many people engaged in all sorts of remarkable pursuits that captured her imagination. How fortunate for us that she always had her camera with her! (Courtesy of the Brewster Ladies Library.)

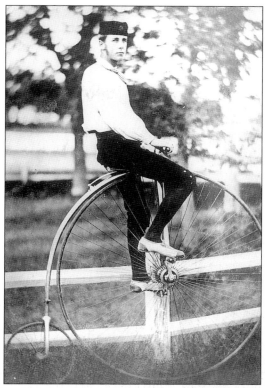

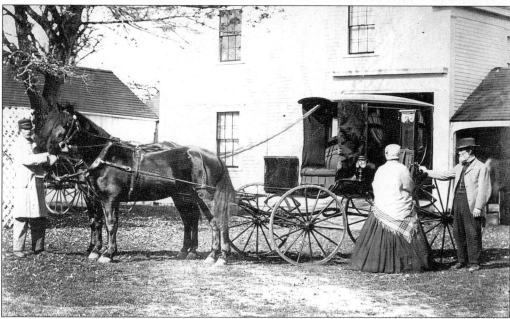

STEPPING OUT IN FRONT OF THE LARGE BARN BELONGING TO ISAAC CROSBY. The enormous house and barn were located on Main Street and Crosby Lane in East Brewster. The house, called Boxwood, was run as an inn in more recent times. Unhappily, it burned down in the 1970s.

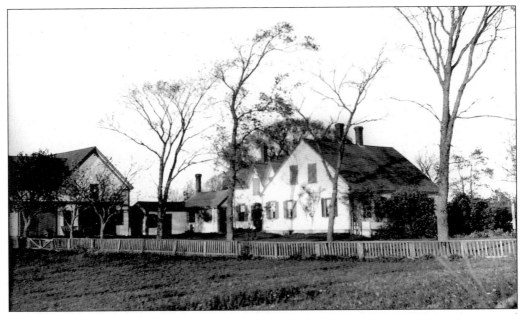

THE OLD HASSARD HOUSE. This farmstead was nestled close to the town hall, but that proved not to be protection enough. When a location for a new police and fire station was sought, the Hassard house fell victim to progress.

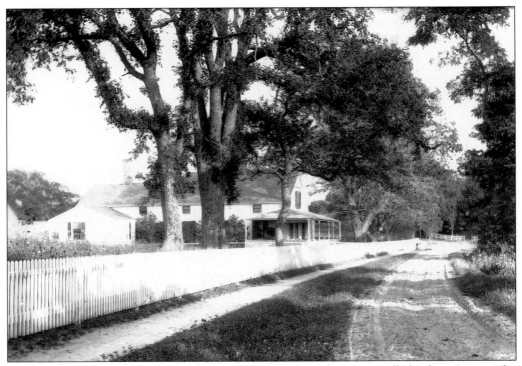

MARY HOWE'S FARMHOUSE ON LOWER ROAD. This beautiful road was called Lobster Lane in the old days. It had a footpath on the left, and the sandy lane had deep ruts made by passing wagons.

A Careful Steed. The steed seems steady, but is the passenger happy? (Courtesy of the Brewster Ladies Library.)

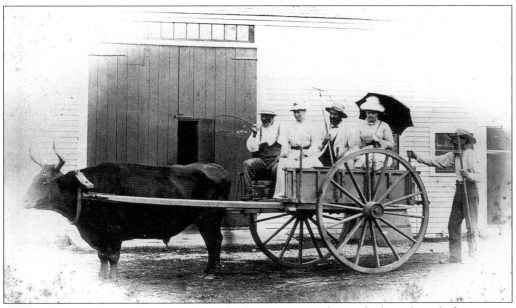

An Ox-Drawn Cart. Two couples and a farmer pose in front of a large barn before setting out for a bumpy ride. Oxen were often used in those days for heavy farm work.

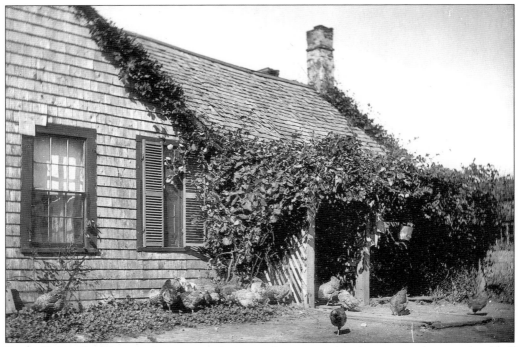

FRED YOUNG'S HOUSE. Long gone but not forgotten, this house stood near the bluff overlooking Cape Cod Bay, just off Robbin's Hill Road.

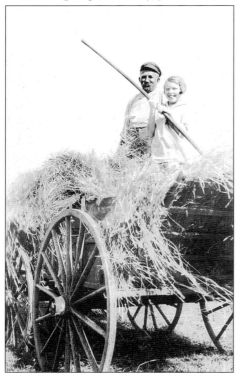

FRED YOUNG BRINGING IN THE HAY AT PINECROFT FARM ON LOWER ROAD. The year is 1927. (Courtesy of Ruth Eddy.)

THE INDEFATIGABLE FARMER FRED YOUNG. Father of six, Fred Young is cutting a fine figure. (Courtesy of the Brewster Ladies Library.)

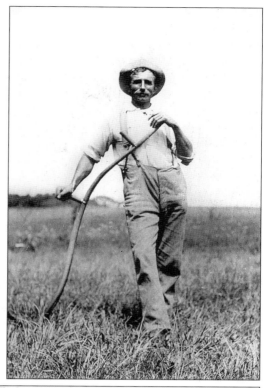

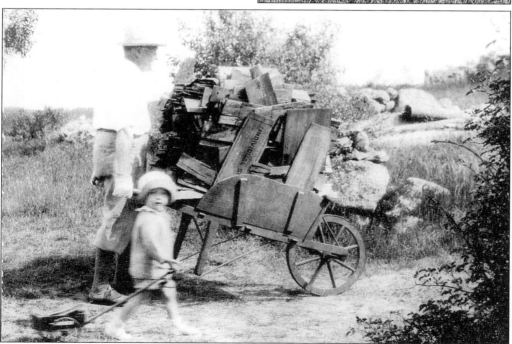

MIMI CLEVERLEY AND HER GRANDPA. Mimi Cleverley and her grandfather collect scraps of wood in their wheelbarrows c. 1927. (Courtesy of Mimi McConchie.)

JOHN AND BRIDGET CONSODINE, c. 1910. Born in Ireland, John Consodine came to Brewster in 1860 and, with his wife, began the Consodine dynasty shortly after the end of the Civil War. His son John is the impressive driver of the buggy that took visitors and guests of the inn wherever they needed to go. (Courtesy of J.L. Hughes.)

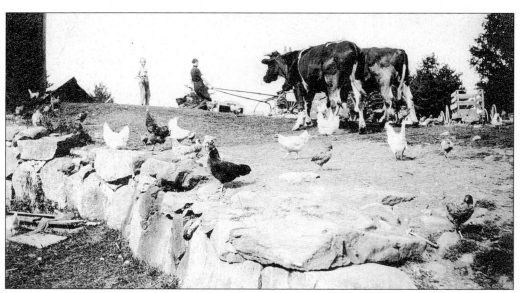

THE OLD CONSODINE FARM. This farm, shown *c.* 1910, was located on Long Pond Road. (Courtesy of J.L. Hughes.)

THE CONSODINE FAMILY. Young Don Consodine, future town treasurer, selectman, and president of the Brewster Historical Society, stands in the middle of this family photograph. (Courtesy of J.L. Hughes.)

GRANDFATHER JOHN CONSODINE. John Consodine is shown with his daughter Katherine Consodine Phinney *c.* 1915. (Courtesy of J.L. Hughes.)

JOHN CONSODINE, 1920. John Consodine is shown waiting for the opening of the Brewster Golf Course. (Courtesy of J.L. Hughes.)

HARRY ALEXANDER. Knowledgeable on local history, Harry Alexander served on the town's Alewife (Herring) Committee for many years. This photograph was taken when the Stony Brook Players were active presenting plays to raise money for the Brewster Ladies Library. His colorful commentary about Brewster is preserved on tape in the oral history collection at the library. (Courtesy of the Brewster Ladies Library.)

MARION DILLINGHAM AHLSTROM, RESPLENDENT IN DEEP PINK. Marion Dillingham Ahlstrom was vivacious and generous to all who knew her and even to those who did not—tourists would sometimes request tours of her house, and she would happily oblige. She inherited the charming saltbox the Dillingham House (built c. 1660) from her relative, the widow of Isaac Dillingham, in 1960. Ahlstrom was the 10th generation to dwell in the homestead of one of the founding settlers of the town.

THE HORSE TROUGH AT THE EGG. This trough was built in 1902, designed by Amy Howe, and constructed by Bert Burgess. It was a gift to Brewster from Roland Nickerson and Herbert Woodworth. The Egg is a landscaped, slightly egg-shaped lawn area at the corner of Breakwater Road and Main Street, a lovely miniature New England village green.

PROBABLY THE HUGE ROCK AT THE WESTERN POINT OF BREAKWATER ROAD. This photograph was taken c. 1893.

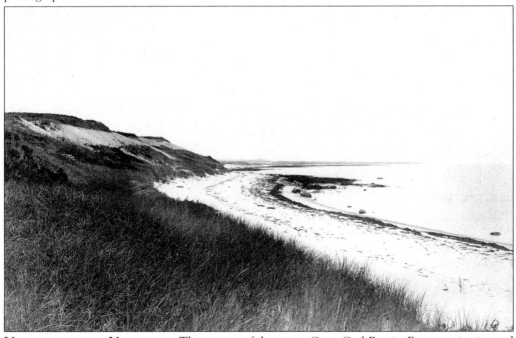

UNTOUCHED AND UNSPOILED. This sweep of dunes on Cape Cod Bay in Brewster is pictured in 1887.

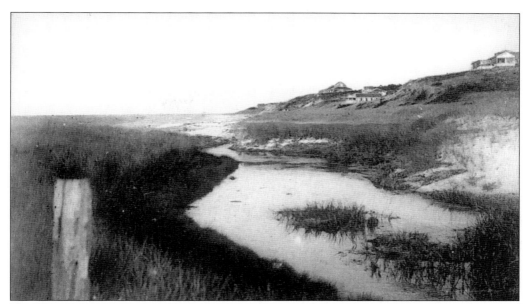

THE TIMELESS BEAUTY OF A BREWSTER CREEK. A creek empties into the sea along Cape Cod Bay. Summer homes guard the shores at twilight.

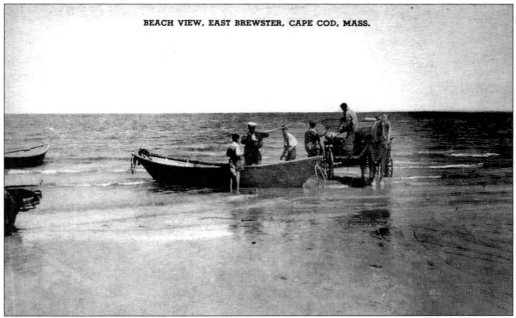

BEACH VIEW, EAST BREWSTER, CAPE COD, MASS.

A BEACH VIEW. This old postcard may be showing a local fisherman off-loading some fish while some youngsters give him a hand with the haul. To this day, fishing is a great part of life on the Cape, although most fish are becoming scarce and fewer people can depend upon it for a living.

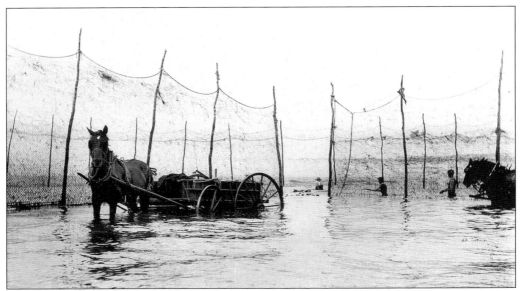

THE FISH WEIRS. All of the towns along Cape Cod Bay were gradually forced out of the fishing business by the advent of larger vessels from competing larger deepwater ports, which could sail farther and weather the storms of the North Atlantic. However, local fishermen never gave up their way of life. Instead, they built huge traps along the tidal shores and captured their fish in these nets, strung between sapling trees stuck deeply into the sand. Starting in the mid-19th century, every town had its picturesque cluster of weirs dotting the coastline. Visitors sometimes rode out in horse-drawn wagons to witness the drama of hardworking men and teams of horses hauling out the mackerel, whiting, pollock, and other victims.

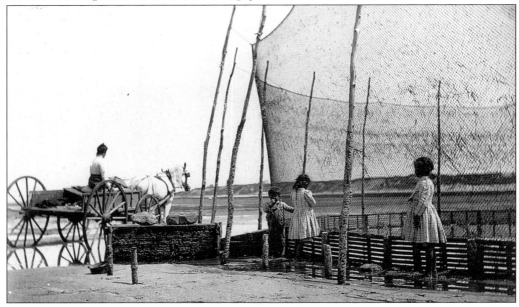

THE FISH WEIRS AT LOW TIDE. It is hard to believe the weirs were so enormous until you saw them at low tide. Examining the daily catch appears to be a curiously fascinating pastime for these girls. (Courtesy of the Brewster Ladies Library.)

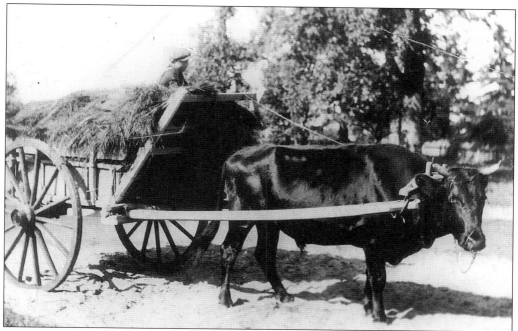

A WAGONLOAD OF SALT MARSH HAY. Raymon Tubman has the reins, but the beast seems to know the way. (Courtesy of Sanford Tubman.)

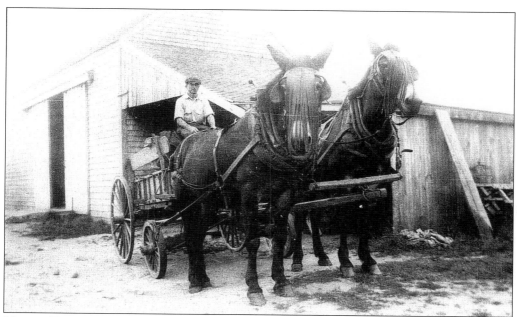

MYRON TUBMAN PREFERRED HIS HORSES AND WAGON. Myron Tubman built a house down the street from his brother, and together they farmed the land. (Courtesy of Russell Bassett.)

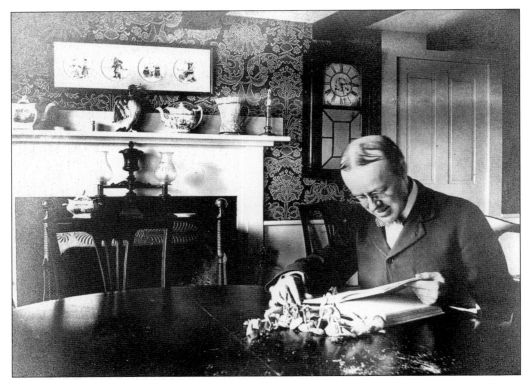

GRANDFATHER THORNDIKE READING AT THE DINING ROOM TABLE. This photograph was taken in the house where the Eddy sisters grew up. All three sisters have made important contributions to the town over the years, serving in town government and making major contributions to the Brewster Conservation Trust, the Brewster Ladies Library, and the Brewster Historical Society. (Courtesy of Ruth Eddy.)

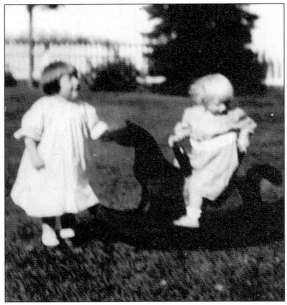

A VERY YOUNG MARY LOUISE (LEFT) AND JEAN. In this view, Mary Louise and Jean Eddy play on a treasured rocking horse. A few years ago, they presented it to the Brewster Historical Society. (Courtesy of Ruth Eddy.)

RUTH EDDY TAKING HER DOLL FOR A STROLL, 1929. Ruth Eddy lived with her sisters on Lower Road in a handsome white house that was then the residence of her grandparents, Augustus and Cora Thorndike. Ruth became Brewster's third lady selectman in 1987. Previously, she had served as town clerk, treasurer, and tax collector. (Courtesy of Ruth Eddy.)

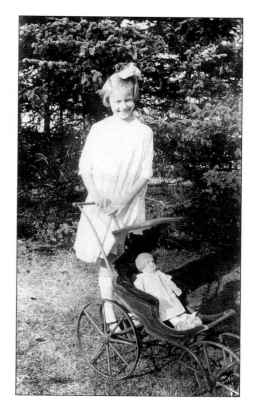

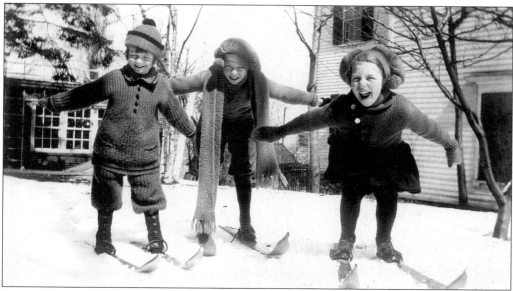

RUTH (LEFT), MARY LOUISE (CENTER), AND JEAN EDDY. The Eddy sisters adored playing outside at any time of year, as seen here on their skis in 1926. (Courtesy of Ruth Eddy.)

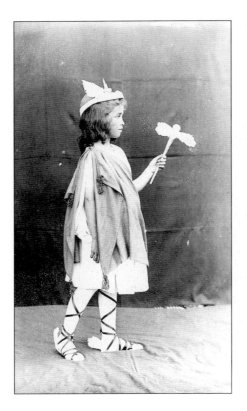

LUCY WOODWORTH. Aspiring actress Lucy Woodworth is shown holding a torch. (Courtesy of the Brewster Ladies Library.)

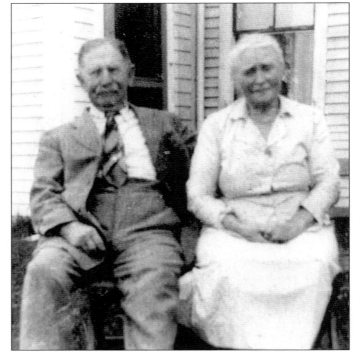

AT HOME ON STONY BROOK ROAD, C. 1930. Herbert F. Foster, eldest son of Capt. Jonathan Foster, is shown with his wife, Eliza May (Chase). Herbert never went to sea and lived his entire life at the Stony Brook house. Eliza May was active in Brewster civic affairs and was president and, later, historian of the Brewster Women's Club.

HARRIET C. DUGAN AND CARO ATHERTON DUGAN. Caro Atherton Dugan took many of the early photographs used in this book. Dating from the late 1800s, photography was generally not a hobby taken up by young ladies. Using glass-plate negatives and fairly large and clunky cameras, this lady was undaunted. She took her apparatus into the fields and byways in every corner of Brewster to record for posterity the moments time stood still for her camera. Her collection eventually came to the Brewster Historical Society.

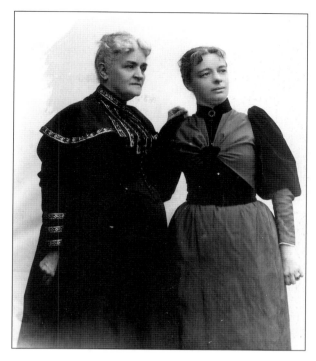

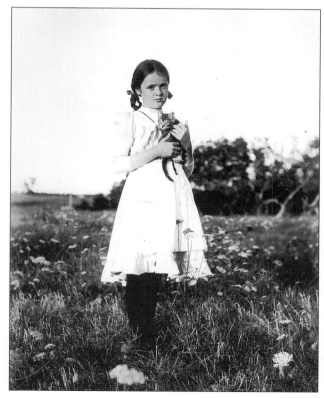

STANDING IN A MEADOW OF WILDFLOWERS. This photograph shows Mary Brett and a friend.

THE J.R. WIXON HOUSE AND BARN. Located on Stony Brook Road just off Main Street, this farm was built in the 1860s in the Greek and Gothic Revival styles.

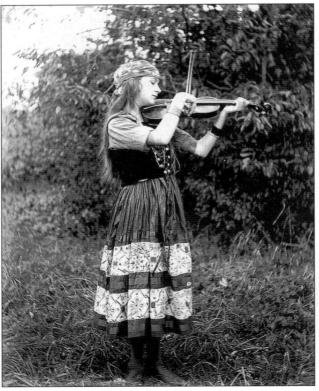

MILLIE ALLEN WITH GYPSY DRESS AND A VIOLIN. Mildred Foster Allen was descended from a long line of Brewster's early seafaring families, the Fosters and the Hopkins. (Courtesy of the Brewster Ladies Library.)

KENELM WINSLOW CROSBY TAKING HIS FIRST STEPS. These were the days when little boys were dressed in ruffled dresses and bows, just like little girls were.

A PLEASANT SUNDAY AFTERNOON VISIT. Enjoying her neighbors, the sociable Caro Dugan could not resist taking a picture whenever possible. She was the great-granddaughter of Capt. Elijah Cobb of Brewster. (Courtesy of the Brewster Ladies Library.)

ANNIE WHEELER WITH FLOWERS. A favorite pastime was pressing flowers in a book and making framed arrangements for decorations and gifts. (Courtesy of the Brewster Ladies Library.)

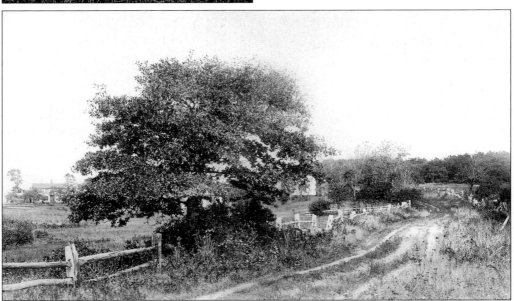

BREAKWATER ROAD. This road, no more than a grassy path leading to the beach, saw plenty of activity once the breakwater was built. The breakwater provided a makeshift harbor for packets to tie up and off-load passengers as well as take on cargo for the big cities. This bucolic scene belies the excitement and commerce created by the arrival of the schooners during the first half of the 19th century. The railroad put the coastal vessels out of business, and the breakwater was left to disappear into the sand.

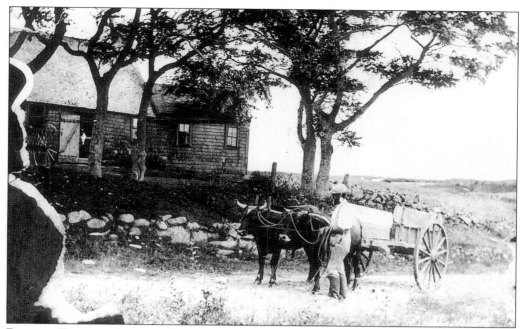

BARTON TUBMAN. Barton Tubman, whose parents came from Ireland, lived on a neighboring farm on Tubman Road. Along with farming, he worked as a blacksmith and plowed other farms in town with his handsome pair of oxen. (Courtesy of Russell Bassett.)

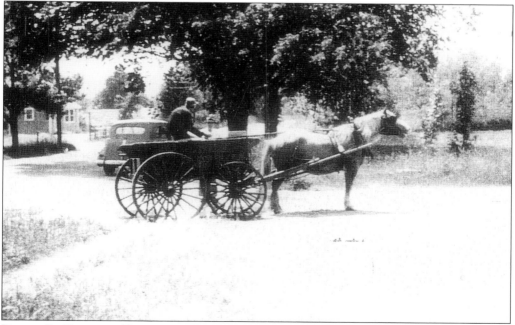

ROGER L. BASSETT, BORN AND RAISED IN HARWICH. Roger L. Bassett moved with his family—a wife, and 11 children—to Main Street in Brewster in 1944. He was a builder by trade, often logging and cutting his own lumber. He loved the outdoors and tended fish weirs on the Brewster flats. (Courtesy of Russell Bassett.)

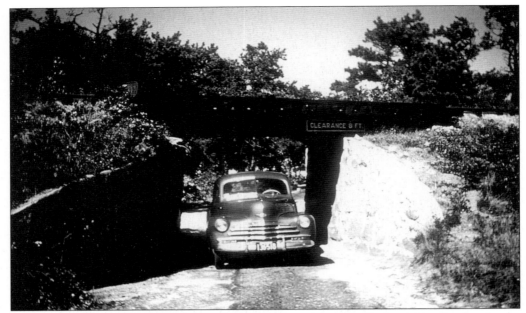

UNDERPASS ROAD, 1949. Underpass Road was named for this distinguishing landmark, the railroad crossing overhead. It was taken down not long after this photograph was taken because it was a safety hazard.

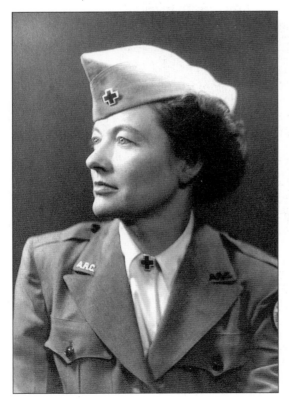

MARY CLEVERLEY. During World War II, Mary Cleverley volunteered for the Red Cross in Europe. Cleverley and her husband, Franklin, both served abroad with the Red Cross.

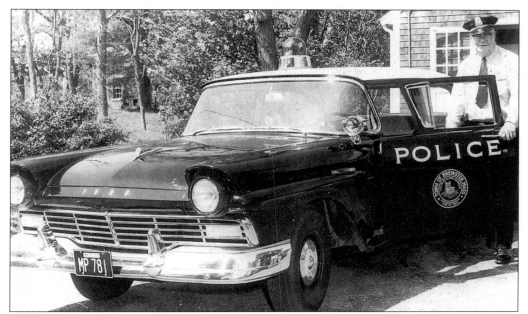

CHIEF HOWARD C. MACGLASHING. The chief is pictured on May 10, 1957, with the first Brewster police cruiser. (Central Cape Press Staff photograph.)

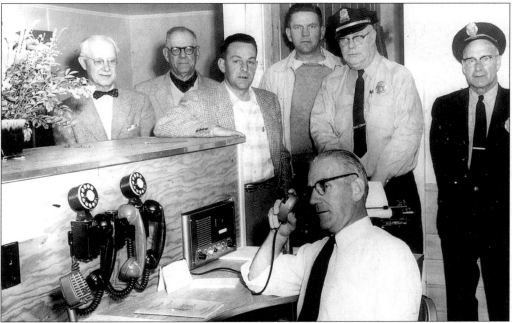

ON 24-HOUR ALERT. The new Brewster Fire and Police Dispatchers Headquarters went into action officially at 12:01 a.m. on Sunday, May 24, 1956, as telephone company personnel switched the town to dial service. Seated is night dispatcher Ewen Sencabough, who worked the first shift Sunday morning. Standing, from left to right, are three unidentified men (visiting officials from neighboring towns), Frank Jones, Brewster Police Chief Howard C. MacGlashing, and John Johnson of the Brewster Board of Fire Engineers. (Central Cape Press Staff photograph.)

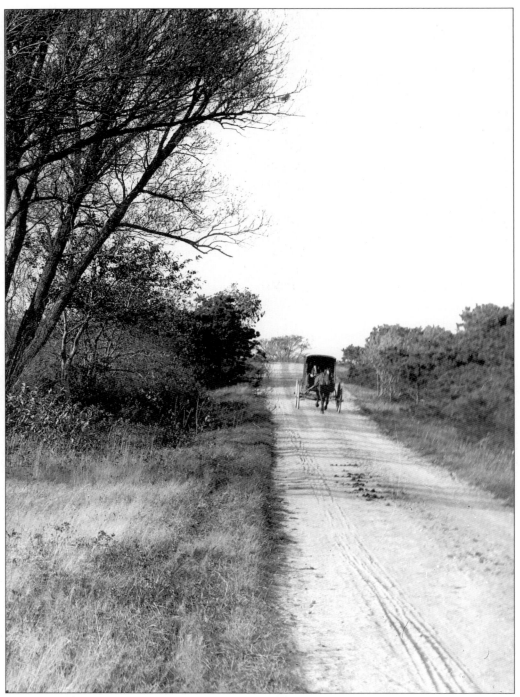

HARWICH ROAD, C. 1887. The principal street from Brewster center to Harwich and South Chatham was this quiet country lane. As the first curator of the Brewster Historical Society, Mary Whitlock, observed many years ago, "I like how I feel inside when I come home to Brewster." May it always be so.